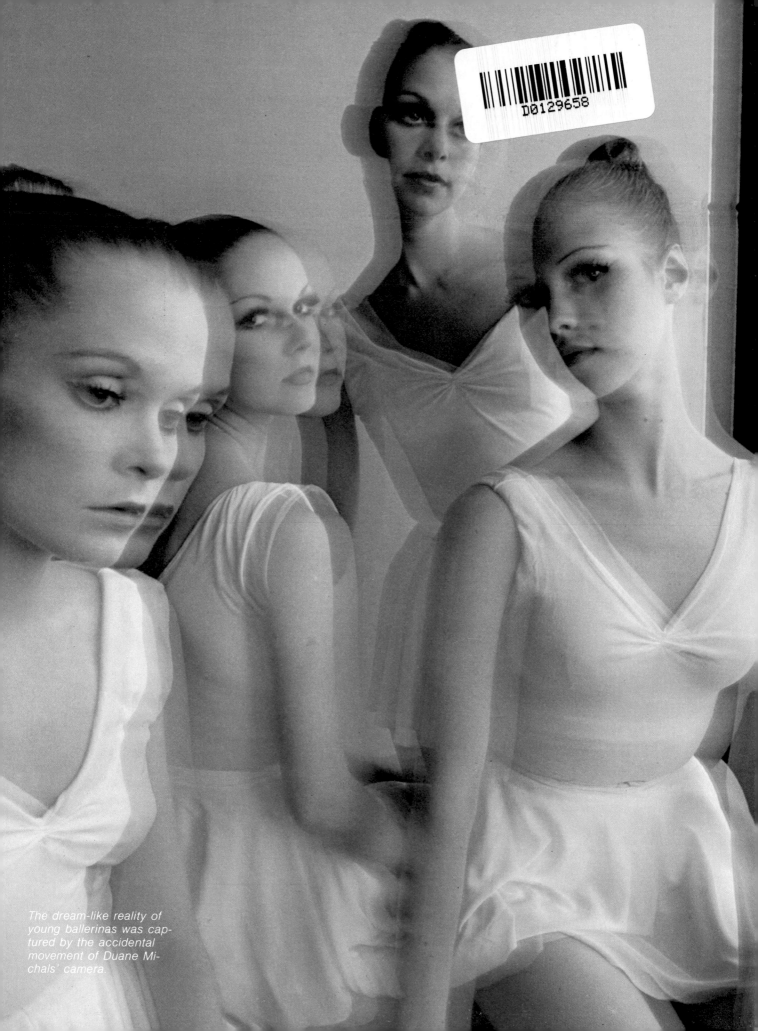

The dream-like reality of young ballerinas was captured by the accidental movement of Duane Michals' camera.

the Photographic Illusion:
Duane Michals text by Ronald H. Bailey
with the editors of Alskog, Inc.

Prepared by Alskog, Inc.
Lawrence Schiller / Publisher
William Hopkins / Design Director
John Poppy / Executive Editor
Ira Fast / Production Manager
Julie Asher Palladino / Design Assistant
Arthur Gubernick / Production Consultant
Lou Jacobs, Jr. / Technical Editor

An Alskog Book
published with
Thomas Y. Crowell Company, Inc.

Alskog, Inc., 9200 Sunset Boulevard, Suite 1001
Los Angeles, California, 90069

Library of Congress Catalog Card Number: 75-12884
ISBN: 0-690-00788-4 Soft cover
ISBN: 0-690-00787-6 Hard cover

First Printing
Published simultaneously in Canada
Printed in the United States of America

This delicate frieze of ballet positions was documented in an improvised studio on a stage made of sawhorses and plywood.

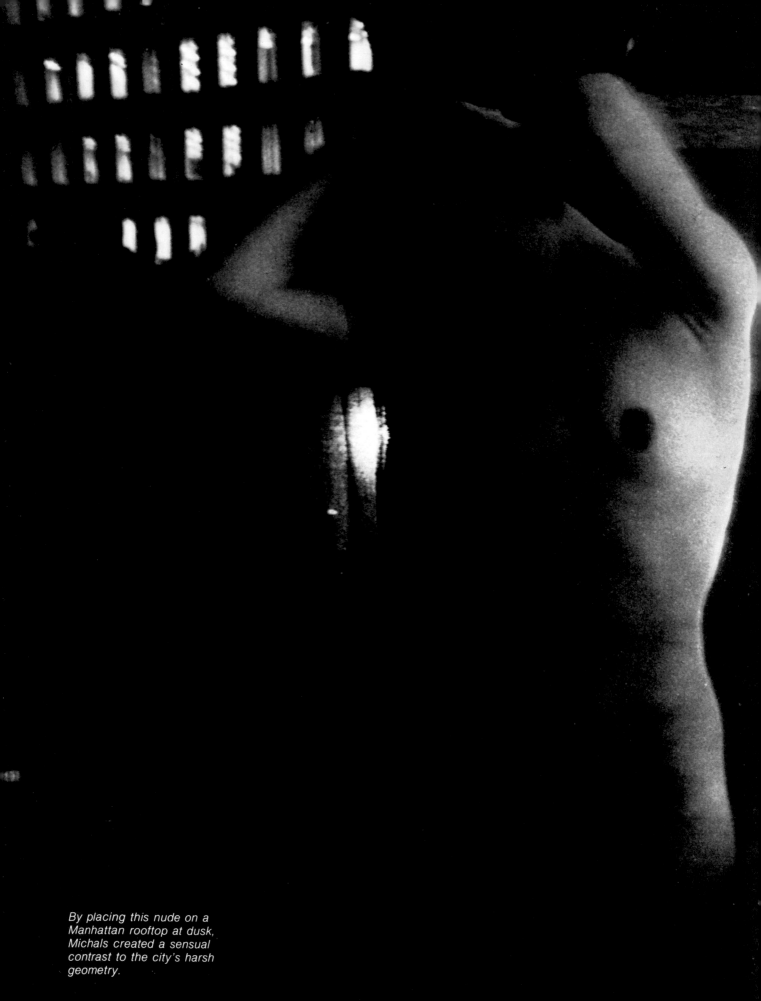

By placing this nude on a Manhattan rooftop at dusk, Michals created a sensual contrast to the city's harsh geometry.

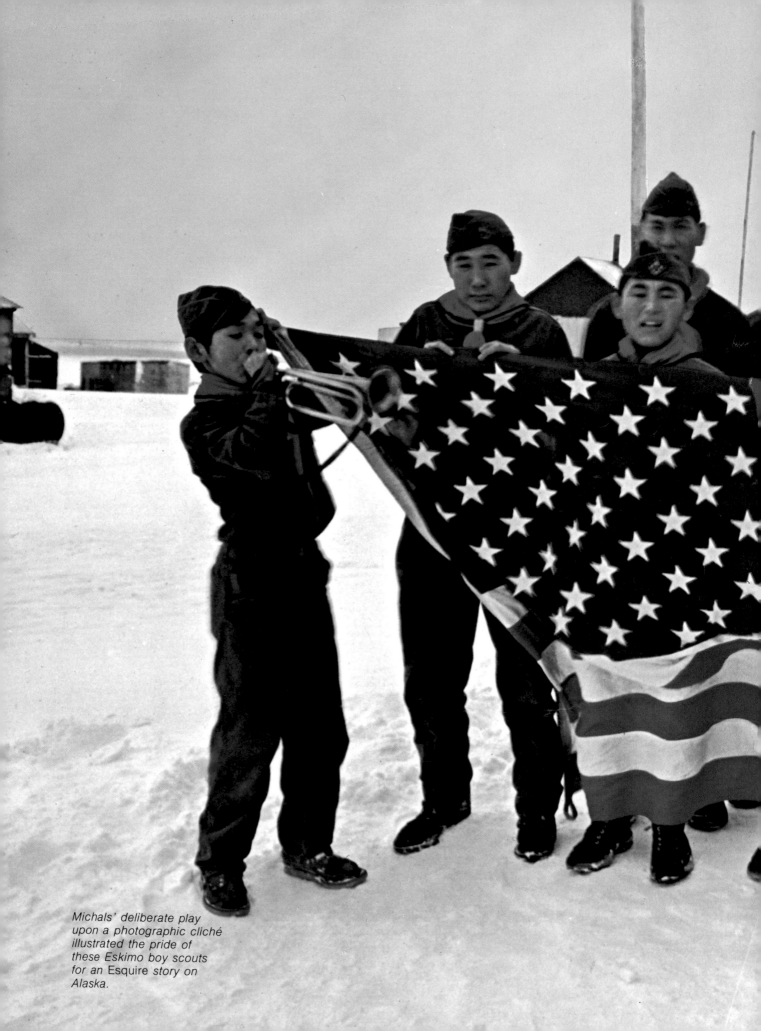

Michals' deliberate play upon a photographic cliché illustrated the pride of these Eskimo boy scouts for an Esquire story on Alaska.

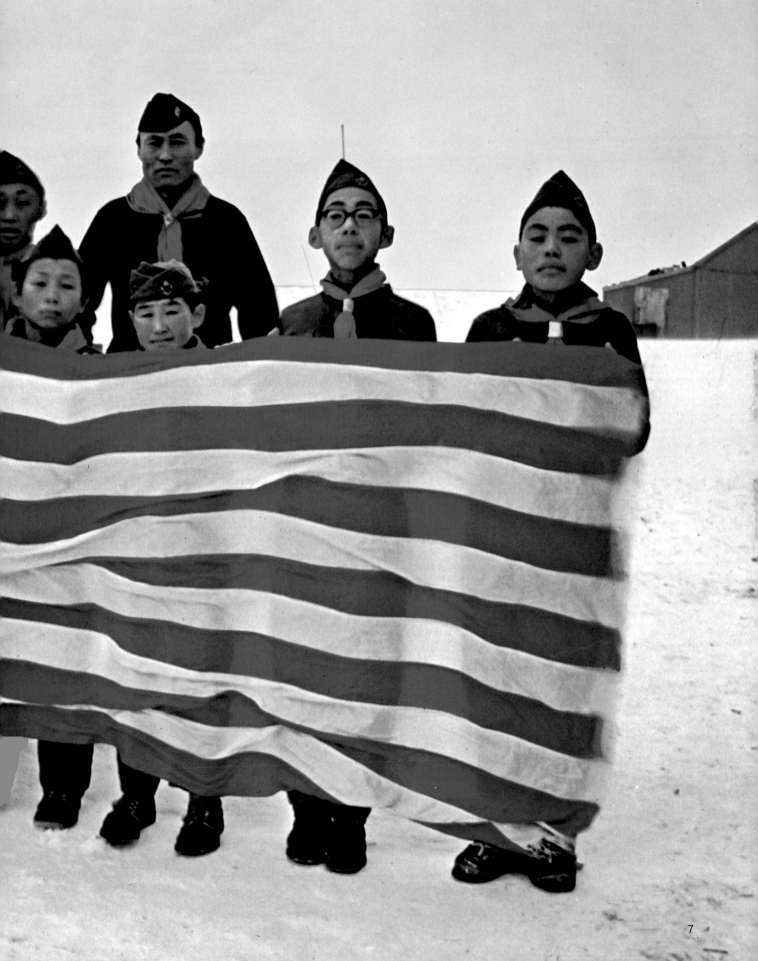

Introduction

Soon after Nicéphore Niépce made the world's first photograph in 1826, the question arose: Is photography really art? Ever since, it has haunted the guardians of other, less widespread mediums. A painting, drawing, carving or print takes longer, requires more dexterity than the apparently easy push of a button, and therefore deserves more respect than a photograph; so we have been told by authorities for whom photography is, in the words of *Newsweek*'s perceptive critic Douglas Davis, "the bad dream of art."

Ironically, while photography was becoming easier and more available than ever before (Americans in the middle 1970's take more than six billion pictures a year), the argument was being settled.

Certain photographers have always regarded

"The Spirit Leaving the Body."

their medium as art—but art as photography, not as imitation painting. Despite the primitive mechanics of daguerrotype. collodion, tintype, calotype and so forth, any number of portraitists in the 19th century produced pictures that have outlived most of the paintings of their time. Mathew Brady, Alexander Gardner and 300 other photographers recorded the War Between the States in images that nobody can dismiss. Around the turn of the century Eugène Atget pioneered the candid documentary photo on the streets of Paris, while in America the work of Alfred Stieglitz inspired two traditions of lasting importance—"straight photography" of people and the land by men and women such as Paul Strand, Imogen Cunningham, Edward Steichen, Edward Weston and Ansel Adams; and photojournalism by Dorothea Lange, Alfred Eisenstaedt, W. Eugene Smith, Henri Cartier-Bresson, Paul Fusco and the many other social documenters who flourished in the days of big picture magazines such as *Look* and *Life*.

Even in the golden age of photojournalism, when pictures served mainly to document grand events and famous faces, the best of them

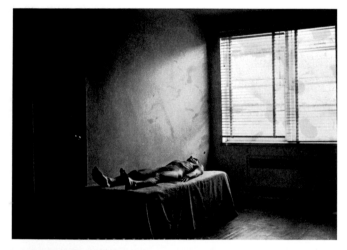

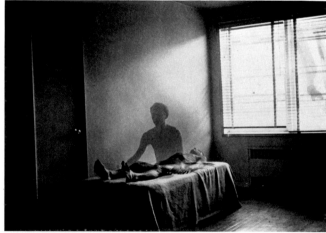

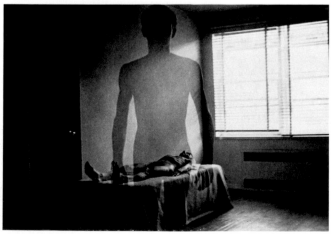

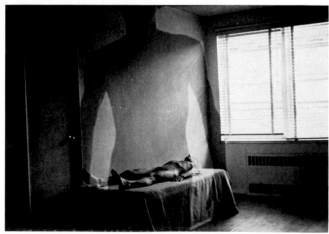

found a balance between reportage and interpretation. They show the imprint of the photographer's personal vision. And it is the personal vision, to which photographers today are turning ever more strongly, that attracts collectors who regard photographs less as a "public" medium of information than as a medium of private expression—an art form. An 1848 daguerrotype of Edgar Allen Poe by an unknown photographer sold for $38,500 in 1974. Prints of some present-day photographers bring prices ranging from $150 to $5,000 and up. In 1970 New York had four galleries devoted mostly to photography; five years later it had at least 15, and the number was growing as well in other cities such as Los Angeles and San Francisco. Increasingly, the buyers of photographs tend to be people who have hitherto collected paintings.

Part of the change has been brought about by Duane Michals, whose work bears the stamp of the surrealists and has been little influenced by other photographers. Photography is the last art form to embrace fiction and invention, after being admired so long for its apparently faithful reproduction of reality. Now that Michals has so effectively demonstrated its power to turn surface reality inside out—as in sequences such as "The Spirit Leaving the Body," below—the embrace includes more photographers every day.

Meanwhile, Michals pursues his own personal vision as a loner and a maverick who has achieved a balance in his life. He likes commercial jobs, taking them with none of the muttering about prostitution that one hears from some artists, and he likes his personal work. He does both with a refreshing disregard for photographic trappings—no gadgets, no studio, no agent. True, he has published three books (Sequences, The Journey of the Spirit After Death, and Things Are Queer); his pictures hang in the permanent collections of the Museum of Modern Art, the National Museum of Canada, the Bibliothèque National in Paris and half a dozen other museums; he has been honored with numerous exhibitions, and his work is reviewed in art journals. Yet his approach remains simple: Make up your own stories, cast your friends as the actors, work in your own living room, use natural light. How he does it is the story of this book.

The story owes much

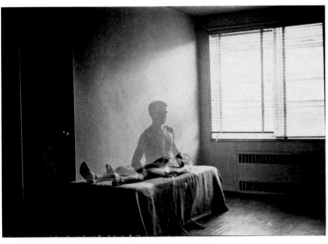 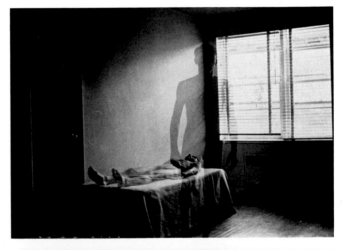

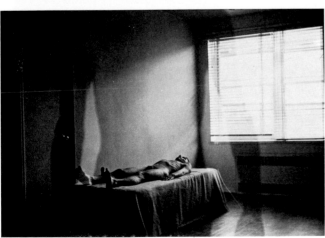 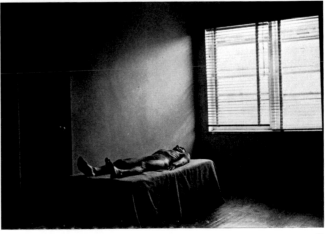

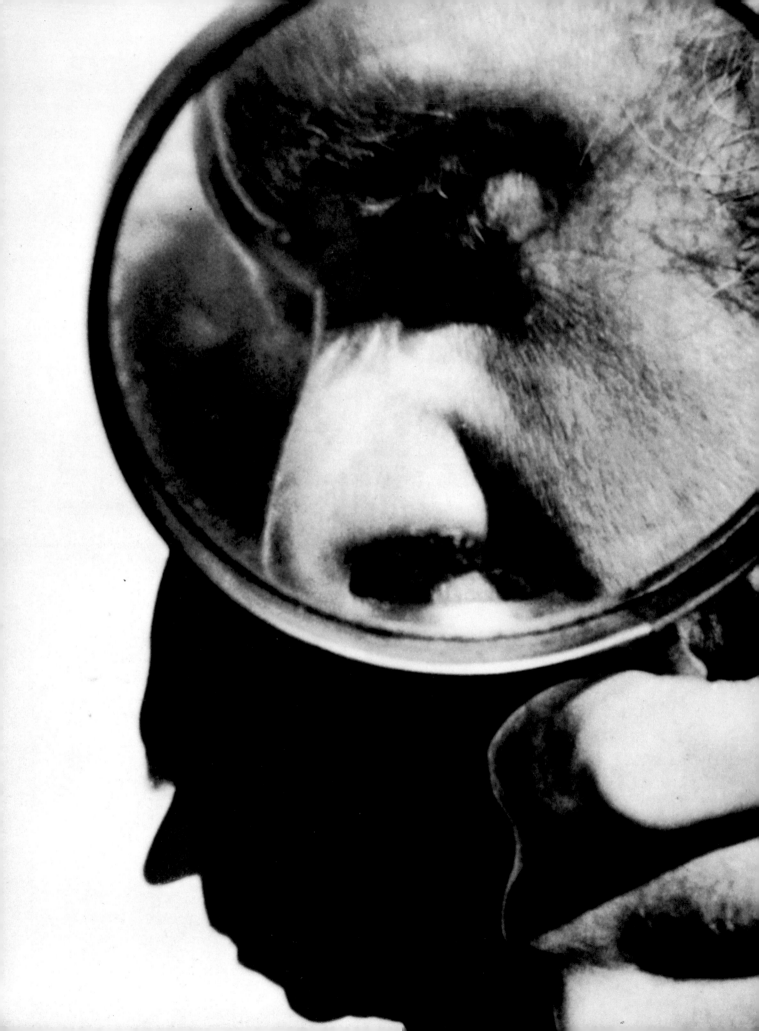

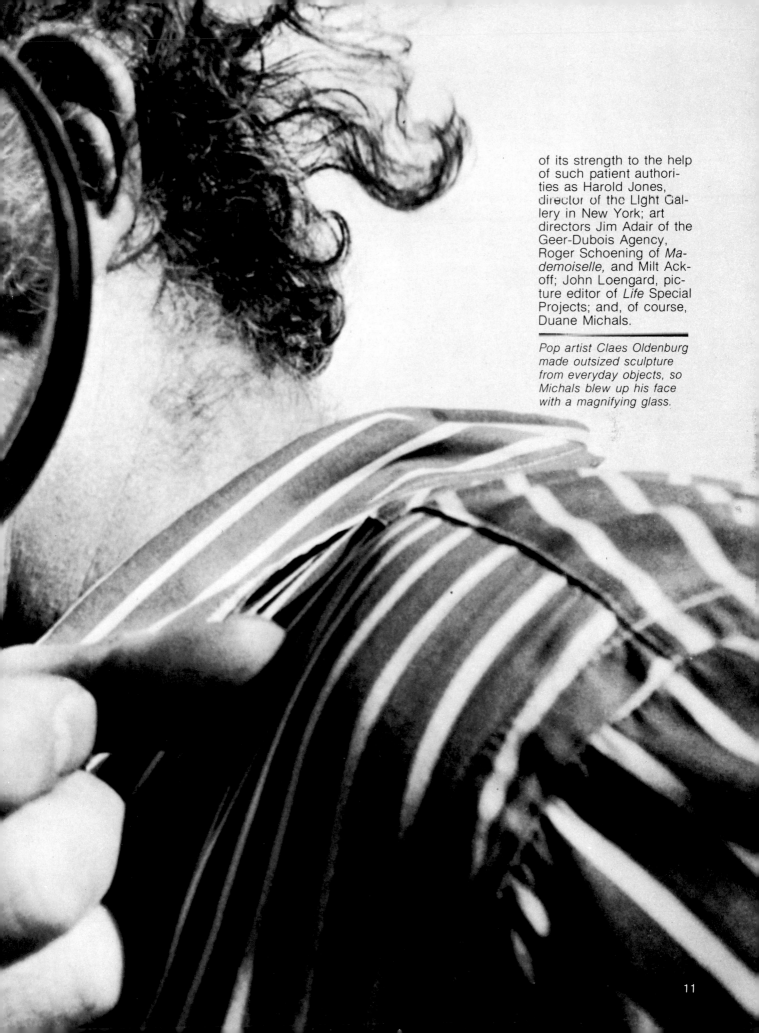

of its strength to the help of such patient authorities as Harold Jones, director of the Light Gallery in New York; art directors Jim Adair of the Geer-Dubois Agency, Roger Schoening of *Mademoiselle,* and Milt Ackoff; John Loengard, picture editor of *Life* Special Projects; and, of course, Duane Michals.

Pop artist Claes Oldenburg made outsized sculpture from everyday objects, so Michals blew up his face with a magnifying glass.

A sun-streaked glade was Michals' stage for recreating the exuberance of these young dancers from the New York City Ballet.

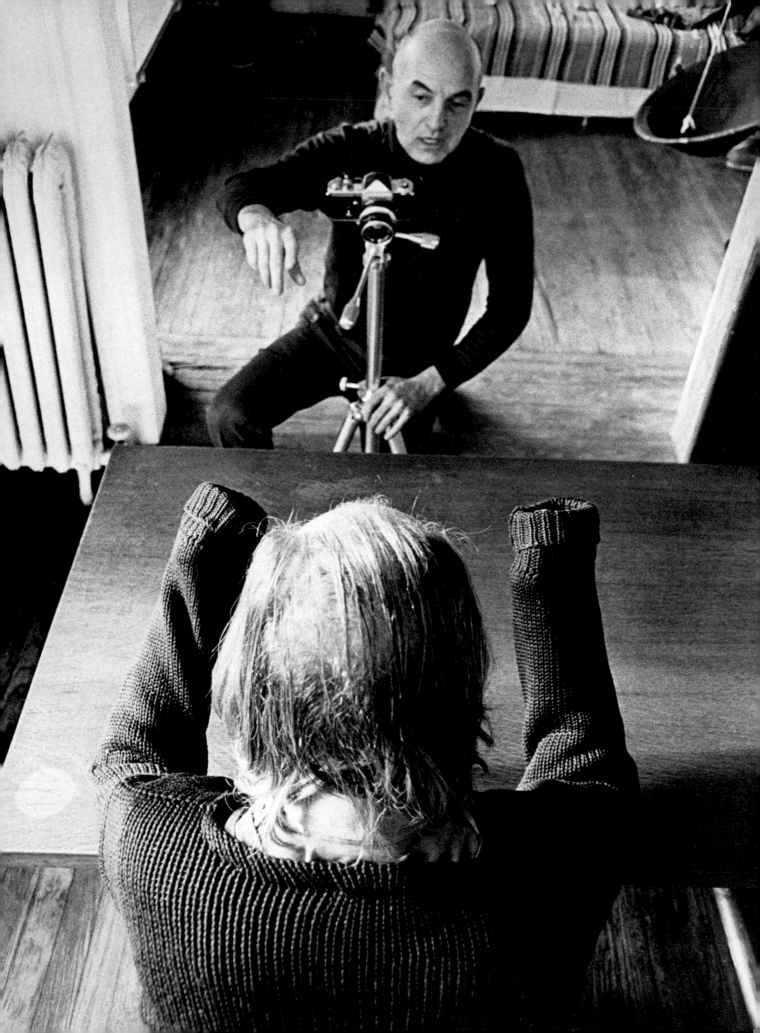

Escape from the familiar

Picture Duane Michals as a character in one of his own sequences. The sequence is a photographic form of Michals' invention, a strip of pictures that tells a strange story, sometimes with the help of words he scrawls under it. Since Michals, his life and fantasies, is the subject of his own work, it is a proper way to meet this enigmatic man who has become one of the most influential photographers in the world.

Frame 1: The living room of Michals' New York apartment. High ceilinged, furnished with a spare elegance, it has full-length mirrors on one wall. These catch the soft light streaming in the front windows and cast an aura of surrealism over the room, as if it were a stage set. (The comfortable apartment is one consequence of his successful career as a workaday magazine and commercial photographer, an occupation that leaves many purists aghast. If you're a collectors' photographer, with pictures in such cit-

adels as the Museum of Modern Art, where a visitor must carefully wash his fingers before perusing them, you simply don't make photographs as a business.) Michals does—with pleasure—for *Vogue, Esquire, Mademoiselle* and *Horizon,* and even for such advertising clients as *Scientific American* and Eli Lilly pharmaceuticals.

Frame 2: Duane Michals appears, seated in a Corbusier chair. He is fortyish, dressed in a white T-shirt, old slacks and bedroom slippers, a bald gnome of a man with elfin ears and dark quizzical eyebrows. (He is not out on the street shooting decisive moments because that's not where he finds his reality. He finds it in his own head. "I don't need to go across the country on a motorbike photographing every gas station," he says. "Every event in my consciousness is stuff for my photographs. I illustrate myself. I can sit in my living room and the universe comes to me.")

Frame 3: Suddenly the blurred figure of a dog

appears at Michals' feet. It is his cocker spaniel Babe. (All of Michals' sequences are mapped out carefully beforehand like movie scenarios, but he likes accident, coincidence, the unforeseen, and he makes use of it. He likes blurs, double exposures—anything that will shake up the viewer's hold on surface reality. He photographs spirits, humans dissolved in light, mysterious boxes that fly away. "I believe in the invisible," he has written. "I do not believe in the ultimate reality of automobiles or elevators or the other transient phenomena that constitute the things of our lives.")

Frame 4: A tripod appears. On it is mounted a Nikon camera so old the black has rubbed bare. Michals stands behind it, with an olive drab Belgian Army bag containing a couple of lenses slung carelessly over his shoulder. (He owns no strobes, couldn't care less about cameras or lenses and has no studio.)

Frame 5: Mysteriously, the man behind the cam-

era is no longer Michals but a friend of his. Michals has switched clothes with the friend and is now himself the subject of the portrait session. (Michals loves self-portraits that throw his identity into question. He has photographed himself as a devil and even as another man—changing places with him by putting on a fake mustache, affecting a cigarette and posing with the man's wife and children. "To me everything is one big unknown," he says. "Who am I? What am I doing here? Where do I come from?")

Frame 6: Closeup of Michals' hand holding a photograph showing two men. It appears to be a double exposure of Michals himself, but the second figure is vaporous, the ghost of a man. The entire image suggests that the foregoing drama was only a fantasy, another form of illusion. (The second man, in fact, is one of Michals' most marvelous conceits—an imaginary alter ego or second self named Stefan Mihal.)

In Duane Michals' vivid

Michals directs a new sequence (left, in a picture taken by Harry Wilks) and peers impishly from the magic box used in an old one (at right, in a photo by Vincent Digerlando, father of the Margaret who found a box).

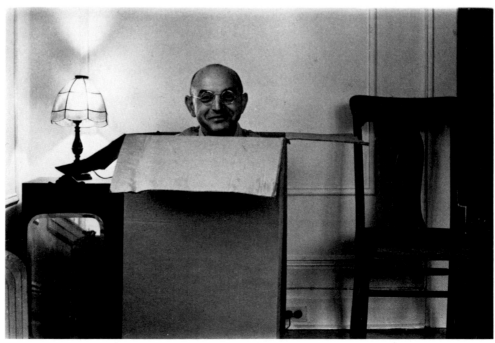

mind's eye, where all his photographs are composed before he ever sees them through a viewfinder, Stefan Mihal is very real. Michals has used him as a character in a sequence and has even toyed with the notion of taking pictures under that name and showing them in a gallery. "Stefan was born the same moment I was born," says Michals. "But we're complete opposites. He could never understand me. If we ever met on the street we would collide like matter and anti-matter."

Michals himself is short, skinny, a bachelor and a loner. He likes books and art and practices a form of Buddhist meditation. He is the kind of man with special antennae who, sipping Scotch in a New York bar, suddenly notices someone's cigarette dangling dangerously close to a potted plant and suggests the plant "must be having a nervous breakdown."

Stefan Mihal, on the other hand, is big and burly, Slovakian by ancestry. He is married, has three kids and lots of hair. He lives in a row house in McKeesport, Pa., drinks beer and watches pro football on TV. "Stefan is my real identity," says Michals. "He is everything I am not. He's the guy I never became."

Indeed, Michals might have become Mihal but for the kind of quirky fate he loves to portray in his photographs. Michals was born in McKeesport in 1932, the descendant of Czechoslovakian immigrants who came there to work in the steel mills. Shortly before his birth, his parents anglicized their name from Mihal to Michals. "My mother was anxious to assimilate," says Michals. "She wanted me to be a WASP."

His mother worked as a maid, and she named him Duane after the son of the wealthy family she served. Duane's middle name, Stephen, was anglicized from the Slovak Stefan—hence the name of his alter ego, Stefan Mihal.

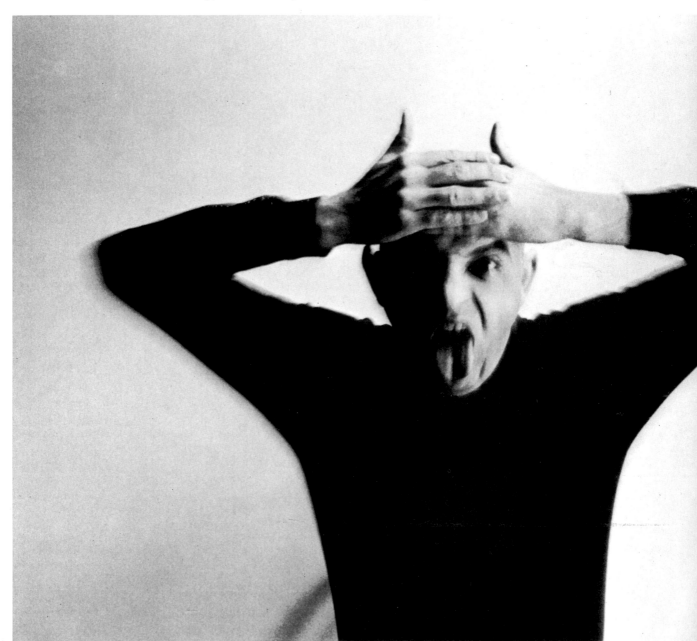

Although Michals insists now that his childhood was happy enough, it was edged with the Gothic themes that haunt his photographs today. For the first five years of his life, Michals' parents were separated. He lived with his grandmother and saw his mother, a live-in maid, only on weekends. His father was a steelworker, struggling in the Depression to get a day's work. When the family finally got together, they lived in a tiny house heated by a coal stove.

"The high school was on top of a hill," recalls Michals. "On one side of the hill was Library Manor where the wealthy people lived. On the other side were all the little houses where we lived. I would go for walks with my mother and run into the other Duane all the time. She would chat with him, but I would stand behind her. I always felt intimidated by him. I wondered about him, what he was like, but never found out. He was about six years older than I was and when he was a freshman in college, he hung himself."

Michals was alone much of the time—his brother wasn't born until Duane was nine—and he made up his own reality. He drew castles and airplanes on the brown paper wrappings in which his grandmother brought fresh bread from the bakery. He drew his own version of Brick Bradford, a comic strip character who lived in caves and had wings and flew. ("I thought that was sensational—to have wings." He wrote poetry.

He made up his own railroad line. He developed an enduring fascination with cities, which he built from stones. He checked out a library book with photographs of U.S. cities so often that the librarians finally wouldn't let him have it any more. Today, Michals keeps on a shelf in his apartment a collection of ornate little colored boxes arranged like a city. And, shopping at the supermarket, he builds urban towers with his groceries at the checkout counter.

Scrawny and introspective, Michals nonetheless possessed an inner daring. At 15 he took off on a bus to look for a job harvesting the summer wheat crop in

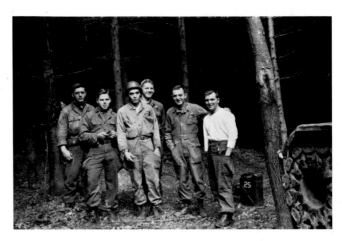

At 40 (left), self portrait as the devil. At 22, (above, second from right) with members of his tank platoon in Germany. At 17 (below), a prize-winning artist.

Texas. He slept on a courthouse lawn without a sleeping bag and mingled with the rough migrant workers congregated in a tiny boondocks town near Amarillo.

"I saw things there I never even knew existed," he says. "It was a great experience. It taught me I had to get away from home."

Michals worked hard. First, because his family was poor—he still remembers vividly the book of train and airplane cutouts he couldn't have because it cost a dollar—and second, because work might be a way of getting out of McKeesport. At 11 he delivered newspapers. At 17 he juggled three jobs—children's clothing shop stockboy, jewelry store clerk, night soda jerk at Isaly's ice cream shop. By then he was acutely aware of McKeesport's social inequities—"the difference between the Hunkies and the WASPS. I became very close to a number of kids in the social class my mother had worked for. I would go to their houses for dinner sometimes. I would sit down

at the table and there would be the maid serving."

Generations of sturdy McKeesport stock have made their way out by becoming All-American football players, but Michals' way out was art. At 14 he entered a drawing contest and won a scholarship to attend Saturday watercolor classes at Carnegie Institute in Pittsburgh. Then his water colors (steel

17

mills, sooty backyards and Times Square, which he had visited only in fantasy) helped him win a scholarship to study at the University of Denver. "In those days it wasn't very *macho* to want to be an artist," he says. "But for me going to college wasn't so much a matter of getting an education as it was learning to stand on my own two feet. If I'd stayed home, I would've become an emotional basket case."

In college he worked as a waiter, managed a pool hall and worked in the library where he could indulge his insatiable appetite for books. He stopped painting but pursued the fascination with modern painters that would profoundly influence his photographs.

After graduation, he was commissioned an ROTC second lieutenant, sent to tank school at Fort Knox and then, to his relief, assigned to Germany, not Korea where armor officers weren't lasting long. Michals was a maverick officer. He mingled with his enlisted men and just missed court martial for entering an off-limits building to buy hot rolls for his platoon. "I was a real fuckup," he says. "I still have this Army nightmare at least once a year. I'm late for formation and everyone's in dress uniform and I'm in fatigues."

Even then, he was questioning the ordinary, finding mystery in what others took for granted. While at tank school in Kentucky, he visited a Trappist monastery and briefly flirted with the idea of becoming a monk. In Germany, he pondered the death of a

Michals' portrait of his brother, Timothy, a Philadelphia psychiatrist, and his niece, Allison.

18

sergeant who was crushed when a car slipped off a jack in the motor pool. "He was a real jerk and I didn't really like him," says Michals. "So I didn't feel that it was a shame. My response was, where did he go? You don't just go away when you die."

After the Army, Michals went to New York, hoping to become a magazine art director. He spent a year at the Parsons School of Design,

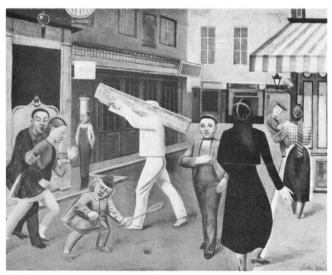

then pasted up some magazine clippings for a makeshift portfolio and lucked into a job as assistant art director at Dance Magazine—his predecessor was being drafted. He worked there a year, learning the trade but barely scraping by on $50 a week. He doubled his salary by mov-

ing to the promotion department at Time Inc., where he pasted up house ads and designed the "blow-in" subscription cards inserted in *Life* and other maga-

On a rare trip home to McKeesport, he photographed four generations of his family.

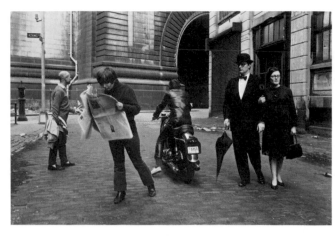

Michals' first consciously posed photograph was virtually a direct copy of the Balthus painting The Street.

zines. By 1958 he was looking around at his comfortable co-workers and asking himself, "My God, is this it?"

Michals heard Russia was opening up to tourism, borrowed $500 from his parents and flew there for vacation. Those three weeks changed his life. "I was the right age for a heroic adventure," he recalls. "I can still remember sitting at dusk in the National Hotel in Moscow, seeing all the gold domes of the Kremlin reflecting the setting sun—bright, glittering gold against the dark sky."

But what truly made the trip extraordinary was his discovery of photography. On impulse, he had borrowed a 35mm camera, an

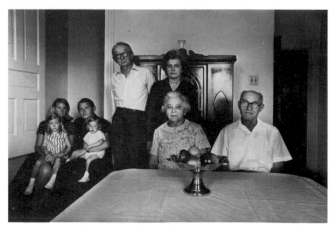

Argus C3, from a friend in New York. As soon as he landed in Leningrad he learned the Russian for "May I take your picture?" Wandering the streets, marveling at the people's openness, he photographed what he saw—a sailor, a little boy who followed him for blocks, the schoolchildren shown at right. He had never taken pictures before and had to guess at the exposures. "I was just taking photographs," he wrote later, "not trying to be a photographer."

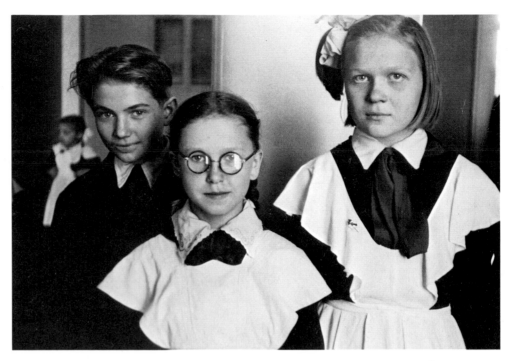

Though Michals has long since abandoned street portraits, the Russian pictures survive today as extraordinary examples of the art—snapshots essentially, but foreshadowing his later work. "His images often speak not only of the reality of the people photographed but in a curious way of the mysteriousness of life itself," the magazine *Contemporary Photographer* would comment. "And that sense of mystery—it is there in the pictures without one being able to specify where: It is in the light, it is in the shadows."

Back in New York, Michals grew restless. He left Time Inc. and joined a small design studio. He also visited a young woman astrologer, who for $10 read his horoscope (Aquarius). "You've just taken a job," she said accurately. "You like to think it's going to be the job you're looking for. It's

not. You're going to go into a whole other field." She also spoke mysteriously of a "very personal idea that will ripen in about 10 years."

The design studio folded after six months and Michals decided the "whole other field" must be photography. He knew he wanted to make photographs for magazines but not how to go about it. Among other things, he didn't know that a young man just didn't step casually into the high-pressure whirl of New York magazine photography. For all he knew, you climbed, a step at a time: photography school first, then a long apprenticeship in the studio of an established craftsman to learn technique and make contacts with art directors. "I didn't know anything," he says, "but then I never wanted to be a Richard Avedon or a Bert Stern—they were not my heroes. I just wanted to do what I wanted to do, and live comfortably."

Blessed in his ignorance, Michals encountered a series of fortui-

tous coincidences and chance meetings, like those that suffuse his personal photographs. Several art directors remembered his work as a designer; others were friends of friends. Most important, at a dinner party in his own Greenwich Village apartment, he met his technical guru—a commercial photographer named Daniel Entin. A friendly, bearded man, Entin had a studio and offered to let Michals use it on weekends. Entin showed him how to use a light meter, taught him to print properly, told him which kind of color film to use for a particular job. "He was very kind to me," says Michals. "If I had a technical problem, he was always there—and he still is."

At first Michals worked with a borrowed Minolta because he couldn't afford to buy a camera. It had a normal 50mm lens and Michals didn't know there was any other kind. He found out about wide-angle lenses one day when, covering a TV program for *Show,* he couldn't encompass ev-

Above, one of his first photographs, made in 1958 in Russia where Michals posed with a propaganda poster (below).

erything he wanted in the viewfinder and another photographer suggested he get a 35mm lens. "What's that?" Michals asked.

By 1961, a year after he had given up design, Michals was living off his photography, shooting for *Mademoiselle, Esquire* and the new magazine *Show.* "It was like a fantasy come true," he says. "It was too much. I kept thinking, they don't know I've just been taking pictures for a few

months. One day I was supposed to go to Canada for *Show* to photograph Lerner and Loewe, who were opening the musical *Camelot* up there. I had these terrible gas pains and couldn't go. It was all nerves."

Michals **loved making pictures —and not just for money.** His most notable personal project from those early days was a self-assignment he called "empty New York" or simply "rooms." The idea of documenting the city was derived from the work of the great French photographer Eugène Atget, but the notion of unpeopled environments as a subject was Michals' own. The project began, in 1964, during the boredom of waiting in restaurants and hotel lobbies for story subjects to show up for their portraits. "Once you put a person in the scene, the viewer automatically looks at him," says Michals. "I was interested in the rooms themselves, the empty spaces— their own identity and character."

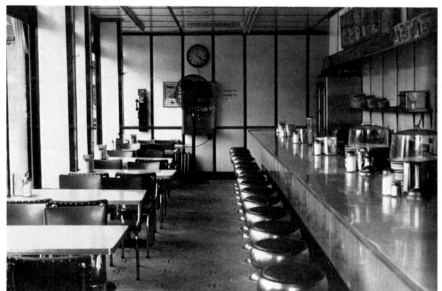

Over the next two years, Michals photographed nearly 70 such spaces—a laundromat, a diner, the back of a bus, a tailor shop, an escalator in Penn Station (shown at right). He worked early in the morning, usually on Sunday, when the rooms would be empty. He often shot from the outside through the plate-glass window, learning to use his arms and body

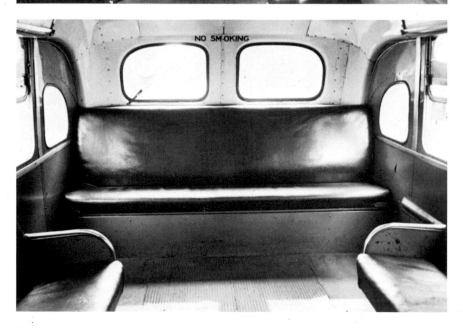

20

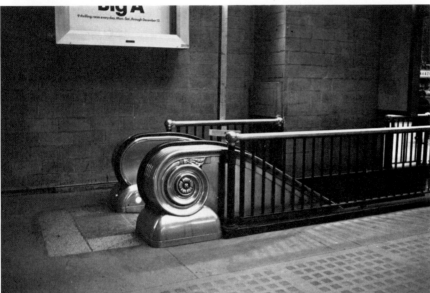

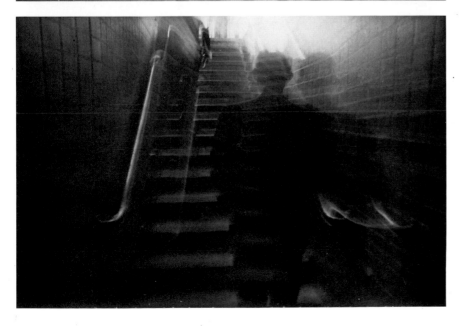

as a shield to block out reflections and shadows.

More and more, the rooms came to represent for Michals the transient reality of the city. (And indeed, he notes with satisfaction, the laundromat is now a boutique, the diner torn down.) They struck him as eerie, surrealistic, as if they were stage sets waiting for actors to appear. "I would think, this is where the tailor comes everyday to do his tailor number. He will wear a tailor's smock and these are all his props."

Seeing these spaces as stage sets led Michals one step further: If they are stages, he reasoned, why not people them with my own actors? He had already made a tentative stab at it. His first consciously set up photograph (page 18) mimicked the artificiality of pose and gesture in Balthus' painting *The Street.* "For me it was a revelation," he says. "I could create my own photographs. Once I realized that, a whole world opened up. I didn't have to wait for something to happen in front of my lens. I could do anything with the camera I wanted to do."

What Michals went on to do is hinted at in the bottom photograph on this page. The stage set is a subway entrance. The actor walks onto the set, his movement deliberately blurred by a slow shutter speed to create a dream-like quality. The photograph was not intended as a single image, but as one in a series that would tell the story of an imaginary chance meeting between two strangers.

Such stories, which he calls sequences, were the beginning of an entirely new photographic form— and the fulfillment of the "very personal idea" in the astrologer's prophecy.

Sequences: Setting up pictures to explore the mysteries

Fiction was not new to photography, of course. Since the daguerrotype, photographers had been altering reality or helping it along a bit by suggesting poses or coaxing smiles out of dour subjects. O. J. Rejlander, a Swedish-born photographer who worked in Victorian England, made photomontages that were at times allegorical and surreal. Nor was the notion of telling a story through a series of pictures particularly startling. In the 1940's and 1950's, W. Eugene Smith, Leonard McCombe and other photojournalists had perfected the essay form, often a narrative with a beginning, middle and end.

What Michals did, beginning in 1966, was to merge these two traditions and carry them to a conclusion that in hindsight seems transparently logical: He made up his own stories, chose settings and actors and, like a home moviemaker, carefully directed the action in front of his own camera. Actually, Michals borrowed consciously from neither tradition. "It just came together," he recalls. "I had a lot of things on my mind, per-

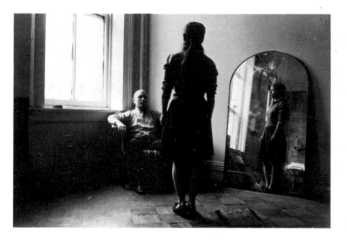

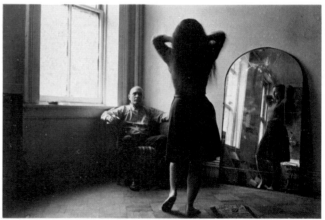

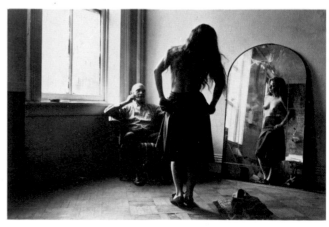

sonal and psychological things, that I wanted to talk about—questions that I was trying to answer—and they couldn't be contained in a single image.''

The early sequences tended to follow a pattern. Consisting of a half dozen or so photographs, they portrayed a tightly compressed drama—a few sequential moments stretched out in time like a Japanese *haiku.* There were certain recurring themes: the power of inanimate objects (Michals' very first sequence showed a young woman being frightened by a door), cosmic and spiritual concerns including death, and male-female relationships. Always the actors and scenario were projections of Michals' own ideas, memories and fantasies. ''Photographers

''For Balthus.''
This voyeuristic fantasy —one of Michals' early sequences—honored the French painter whose work helped inspire him to make up his own photographic stories.

always show you other people's lives, never their own,'' he says. ''Every time I do one of these series I feel I'm putting something of myself on the line.''

The sequence that starts below—honoring Balthus, one of Michals' favorite painters—typifies his approach to the male-female theme. The idea for the story evolved some weeks before as a cerebral patchwork woven from fantasy and his observations of human relationships. The notion was simple but al-

ready tinged with mystery: ''There would be this man watching this woman taking her clothes off, but there would be no touching between them. There would be drama—a hot-cool play-off. I wanted him sitting there very casually smoking a cigarette. I don't know what the relationship is. Did he pay her? Or perhaps it's only his fantasy.''

Only when the mental pictures were fully developed inside Michals' head did he prepare for the actual shooting. The

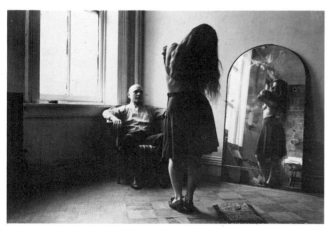

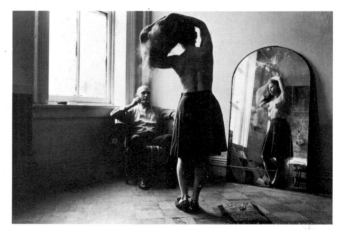

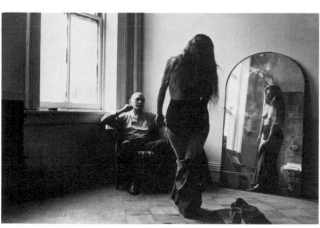

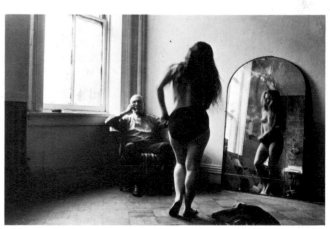

casting was no problem. The bald man was a friend of his ("not a surrogate Duane"), the woman a hired model. He found the setting he wanted in a loft he had visited. "There are certain kinds of spaces I like, certain kinds of light," he says. "When I go to people's places, I'm always casing the joint."

Like a stage, the setting would remain unchanged from image to image. Michals moved the furniture around so the set would consist of three major elements— the chair, the window and the full-length mirror. The mirror would help light the drama by reflecting the soft sunlight streaming in through the window. More, it would enable the viewer to share the man's front-row glimpse of the private strip act.

From behind his tripod-mounted Nikon, Michals directed the drama. His style is always low-key, direct, precise. "This time lift your elbow a little higher. Pull up your blouse so I can see your chin." He asked her to run through the act three times. To save time he kept shooting while she dressed for the next run-through since the gestures would look the same. "After that it was merely a matter of selecting which gestures I liked from the contact sheets," he says. He never reshoots.

The session lasted about two hours. Michals shot fewer than three rolls of Tri-X film, perhaps 100 frames. "Taking the photograph is the easiest part for me," he says. "Before that I may spend three months thinking about something. It's arriving at what I feel and think that's the hard part."

Several early sequences were rooted in more specific events in Michals' life. These events—the senseless deaths of two friends— were among the internal pressures that helped turn him toward the sequence as a vehicle for disturbing ideas and feelings. One friend was a young painter who was fatally burned a few hours after having dinner with Michals, when his cigarette ignited the paint thinner with which he was cleaning his brushes. The other friend died in a street mugging—a fate-crossed event that became the subject of several of Michals' sequences.

"I went to the funeral parlor to look at his body," recalls Michals, "and I realized that wasn't him at all—it was just the plumbing I was looking at. I wanted to know what happened when somebody died. I wanted to know where he went."

One of Michals' answers was the sequence called "The Spirit Leaving the Body" (pages 8–9). A nude male lies on a couch, softly lit by

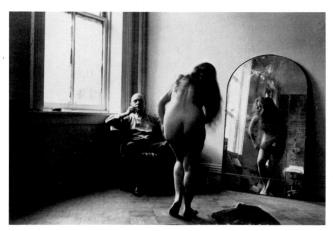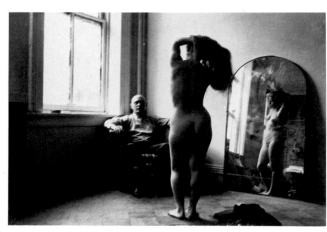

A sequence of portraits caught the elusive identity of Michals' friend from McKeesport, Andy Warhol. The king of pop art collaborated in destroying his own face by moving his head back and forth faster and faster as Michals made several exposures from 1/60 second to 1/4 second. "The last one," says Michals, "is more Andy Warhol than the one in which you can count the bumps on his nose."

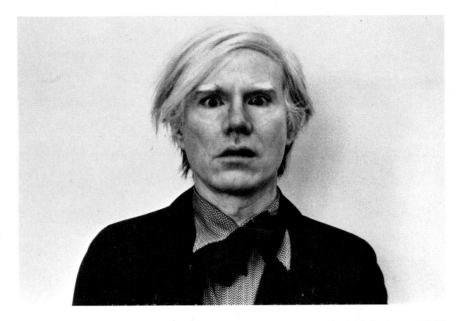

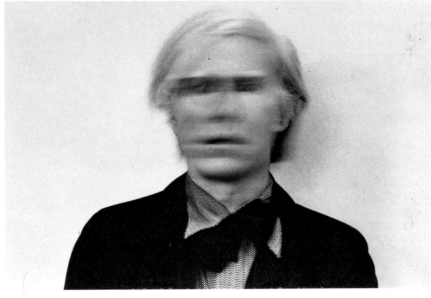

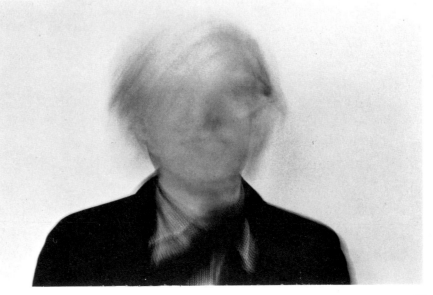

a nearby window. Suddenly, a ghost-like image rises from the body—the result of a series of intentional double exposures in Michals' camera. "This is literally what I think happens when you die," says Michals. "It's my see-Dick, see-Jane mentality. The body is just a big machine, a vehicle for the spirit."

In this sequence the casting of the actor was dictated by the setting. Michals wanted an empty apartment and he ran into an acquaintance who was just moving out of his own place. The man was sympathetic to the idea of the sequence and also agreed to serve as the subject.

For another sequence on death, Michals enlisted his father and his grandmother, who died not long after the shooting. "When I was just starting out," he says, "it was kind of difficult to walk up to a stranger and say, look, you're going to be the spirit leaving the body. Right off that sounds a little banana-land."

The inspiration for another sequence, "Margaret Finds a Box" (pages 26–28), stemmed

 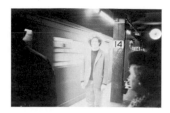 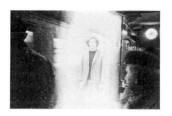 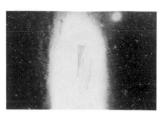

from his own boyhood. When someone in the neighborhood got a new piece of furniture, Michals would cop the cardboard container and pretend it was a castle or even an airplane. In the sequence, Margaret, the daughter of a Michals acquaintance, discovers such a box in her living room, climbs in and closes the flaps. Thanks to her father, who was perched on a ladder offstage to lift wires attached to it, Margaret's box actually flew away—without Margaret, who had jumped out to lighten her father's load.

Everything was meticulously worked out in Michals' mind ahead of time, except for Margaret's cat. It became curious, made an ap-

pearance in the third picture and stayed around until the box lifted off— much to the delight of the photographer, whose careful manipulations always leave room for such serendipity.

Michals prefers to perform his magic in the camera—he never crops his own photographs—but some of his ideas are so cosmic that he must resort to darkroom trickery. In "The Human Condition" (above) he wanted to show literally his belief that "we are all stars." He took to the darkroom two negatives —one of his subject standing in a dark subway and another shot from a stock picture of a constellation he found

"Margaret Finds a Box"

in an astronomy book. In the enlarger he dodged the human figure, withholding light from it during printing, so that it would begin lightening with the second picture and disappear by the fifth. He also sandwiched the negatives of the man and the stars, beginning

with the third picture. As he worked, Michals noted the coincidental resemblance between a clock in the subway station and a tiny satellite star in the astronomy picture. By flopping the star negative he achieved a happy bonus: In the final images not

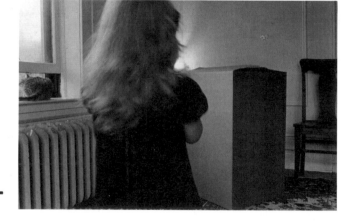

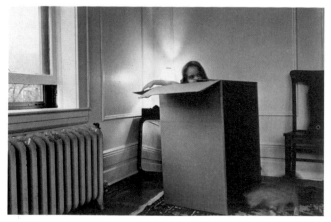 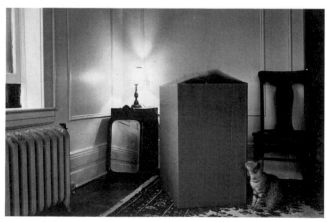

only the man but the symbol of time itself evolves into astronomical eternity.

His sequences received their first public showing at the Underground Gallery in New York in 1968. They were published two years later as Michals' first book, *Sequences,* and at the same time were given full-scale certification as "art" in a one-man show at the Museum of Modern Art. Sequences created a stir, partly because critics didn't know what to make of them.

For one thing, direct precedents were hard to come by. The comic strips, perhaps. The movies certainly, though Michals insisted, "What I have to say is like *haiku;* it's just an instant. To make *War and Peace* out of *haiku* would just destroy it." Michals himself later uncovered a kind of precedent in the work of the 19th century photographer Eadweard Muybridge, who did sequential studies of the human figure and animals in motion.

Many purists labeled the sequences "literary"—a photographic taboo. Michals was illustrating ideas instead of

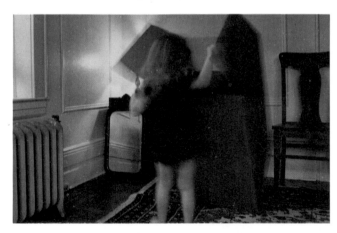

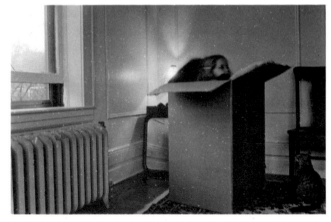

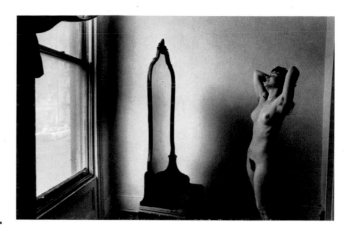

"Persona."
To illustrate his fantasy about vanity, Michals double exposed the nude woman so that her own self image comes to life. The image steps out of the mirror, touches her breast, then leaves her—alone and shaken with guilt (next page). By using a phallic-shaped mirror, Michals was able to suggest masturbatory fantasy without being sexually explicit.

the thing itself, and he was even supplying titles to make certain the viewer got his point. "I think they're a lot of fun," says John Loengard, the former *Life* photographer widely recognized as an astute critic of pictures. "They work. But from an Olympian point of view I'm not sure they're photographs."

Actually, the sequences are seldom as literal as they appear at first glance. The sum of the images is greater than the parts and often points beyond itself so that the photographs take on lives other than the ones Michals intended. "Their meaning remains elusive," observed the critic A. D. Coleman, "but all of

these sequences seem to touch hidden buttons in the psyche." They become a kind of photographic Rorschach test in which the viewer must fill in his own meanings and perhaps reveal something of his own psychic makeup. In fact, the book *Sequences* has been used for just that purpose in group therapy in at least one mental institution.

Stories such as "The Incubus", which begins on page 31, put the viewer through a series of changes. Seen one image at a time, they have the power, in Michals' words, "to make people giggle, then all of a sudden go silent." He prefers to show his sequences in slide presentations or in books, one

image to a page. If they are mounted at an exhibition, viewers tend to skip impatiently through the photographs and sneak a look at the punch line in the final frame, defusing the power of surprise.

In "The Incubus," the strip starts off humorously enough. A man is playing solitaire when suddenly a horse's head appears. The man whirls but the apparition has quickly switched sides —an old cartoon trick. Michals has had his fun; now the terror sets in. The horse actually symbolizes the man's internal demon, his incubus, and the demon attempts to smother him. The final frame implies it was only a dream, but the terror lingers on. The episode grew out of Michals' friendship with a schizophrenic. "I believe in many realities," says Michals, "and this guy lives in his own reality. He deals with his own demons and to him they are real, three-dimensional."

In 1974 Michals broke another photographic taboo. He began writing his own captions for the sequences in longhand. Great photographers aren't supposed to write

captions—tradition says a photograph ought to stand on its own. But Michals decided that a combination of words and photographs could better communicate what was on his mind, just as eight years before he had decided the sequence could say more than the single image.

The first show of his photographs with writing appeared at New York's Light Gallery in late 1974, further confounding both the purists and longstanding concepts of photographic reality. "He's changed the way we see," says Light's director, Harold Jones. "He's invented a way of telling us things we hadn't thought about." A writer from *Paris Review* was particularly impressed by the homespun authenticity of Michals' longhand captions, especially the occasional misspellings.

It was not only the writing that evoked comment. Several of the new sequences were more erotically explicit than Michals had ever been before. There was a boot fetishist and a man's tongue that turned into a penis and, in a series entitled "Blue Sequence," photographs of

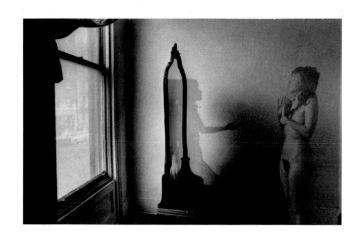 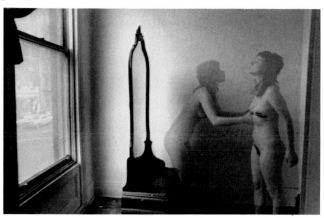

the act of fellatio. One viewer, who brought his mother to the show, told Jones, "Next time I'll call ahead first."

In one sequence, "A Man Talking to God" (pages 30–34), only the words were new. Michals had made the photographs several years before, intending them as the story of a man talking to himself. He double exposed each frame, moving the subject to create the man's encounter with his white-masked inner self. The man, like many of Michals' subjects, was photographed in the nude since Michals likes the esthetics of the human figure, and the absence of clothing and other identifying characteristics enhances the abstraction he seeks. In this instance the sequence hadn't worked out to his satisfaction, even though he especially liked the surrealistic way the black box seems to show through the double-exposed figure on the right. When Michals decided to do a sequence on a man's conversation with God, he remembered the old pictures, pulled them out of his files and wrote the dialogue for them.

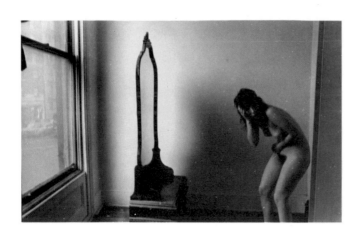

My God, you look just like me wearing a silly mask.

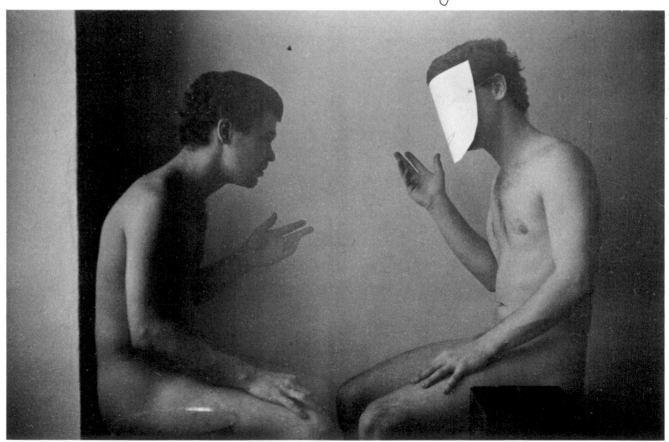

"A Man Talking to God."

I am you wearing a silly mask.

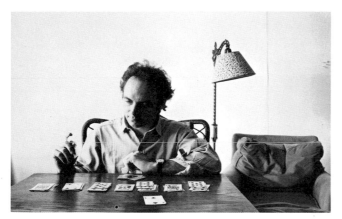 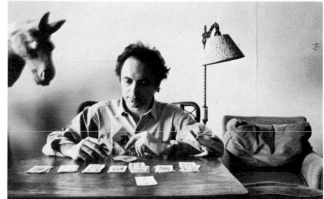

"The Incubus."

If that's true, why don't I know it?

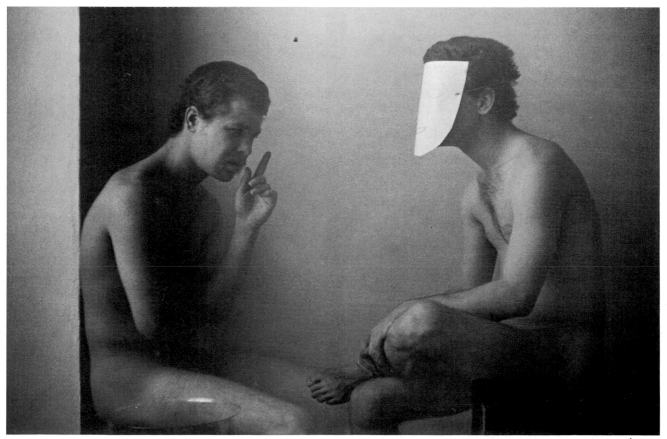

you choose not to know it. You'd rather make noise.

31

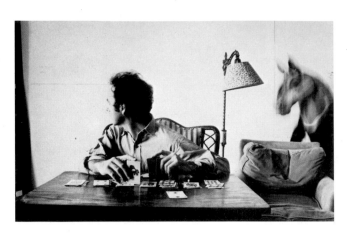 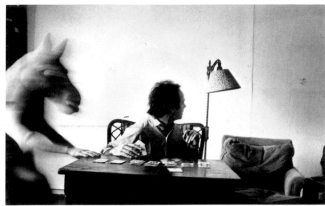

I know who I am.

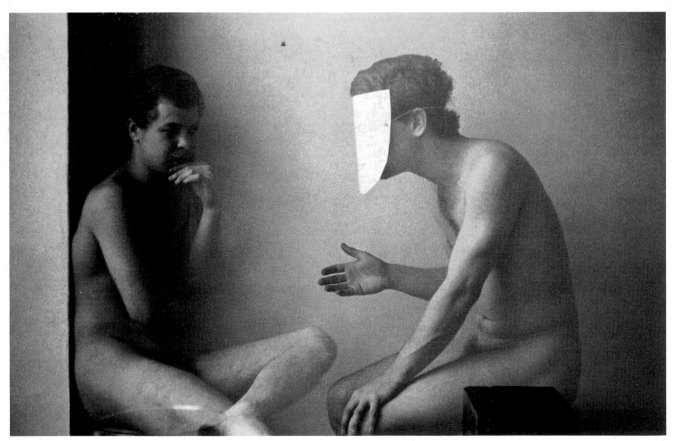

You don't know that you don't know.

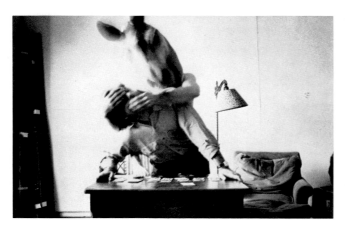 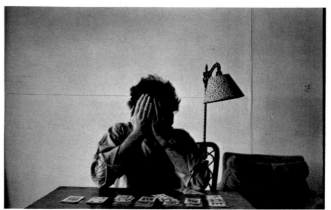

Tell me, what are all these people and trees and stars doing here?

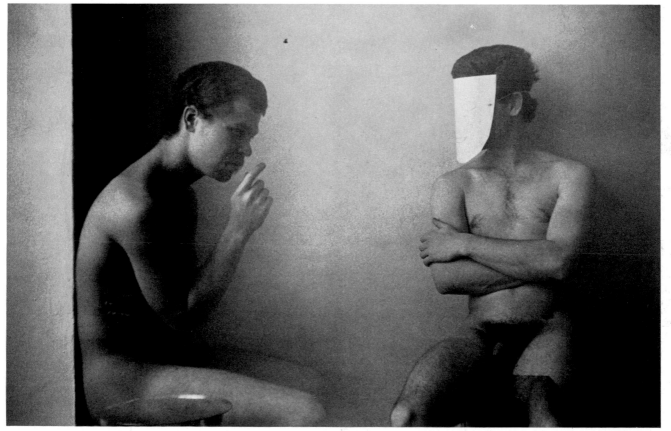

They're doing what we're doing. I'm talking to myself.

"The Creation."
The Michals version of how it all began wryly sug-gests—through sandwiched negatives conjured up in the darkroom—that every-thing emerged from the apple. He found his Adam and Eve at New York's School of Visual Arts where he was lecturing. He felt "they look like Renaissance people" (next page). "There's no subject I can't do," says Michals. "If I want to do The Flood, I can do it in my bathtub."

I don't understand any of this.

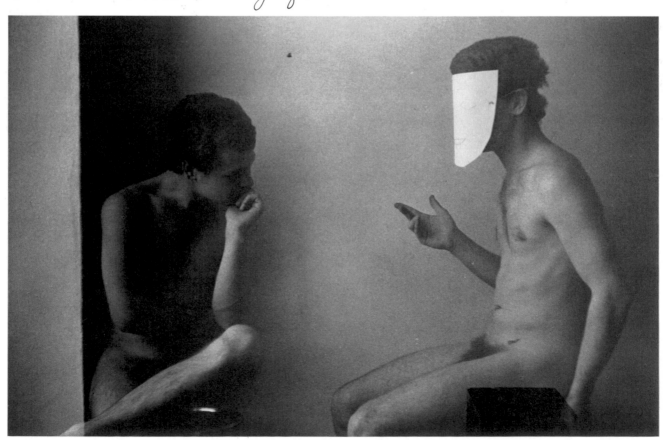

It doesn't matter

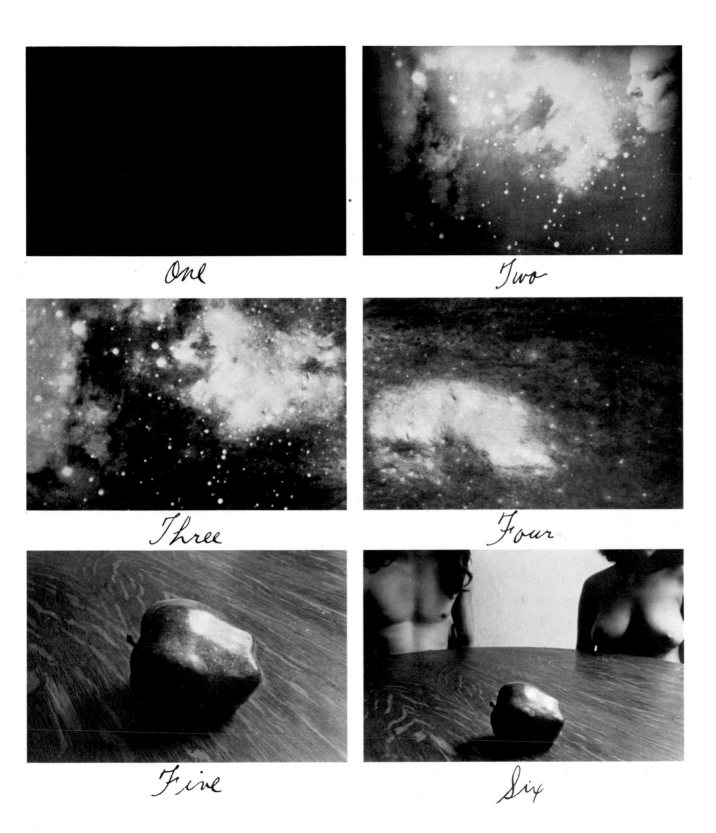

One

Two

Three

Four

Five

Six

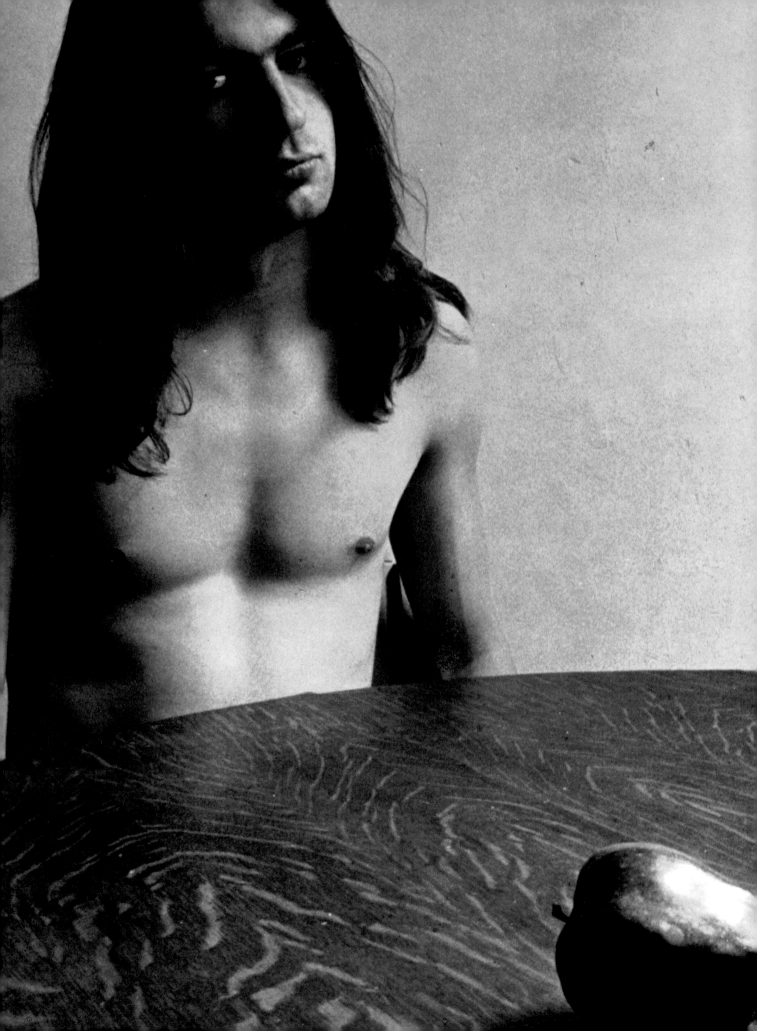

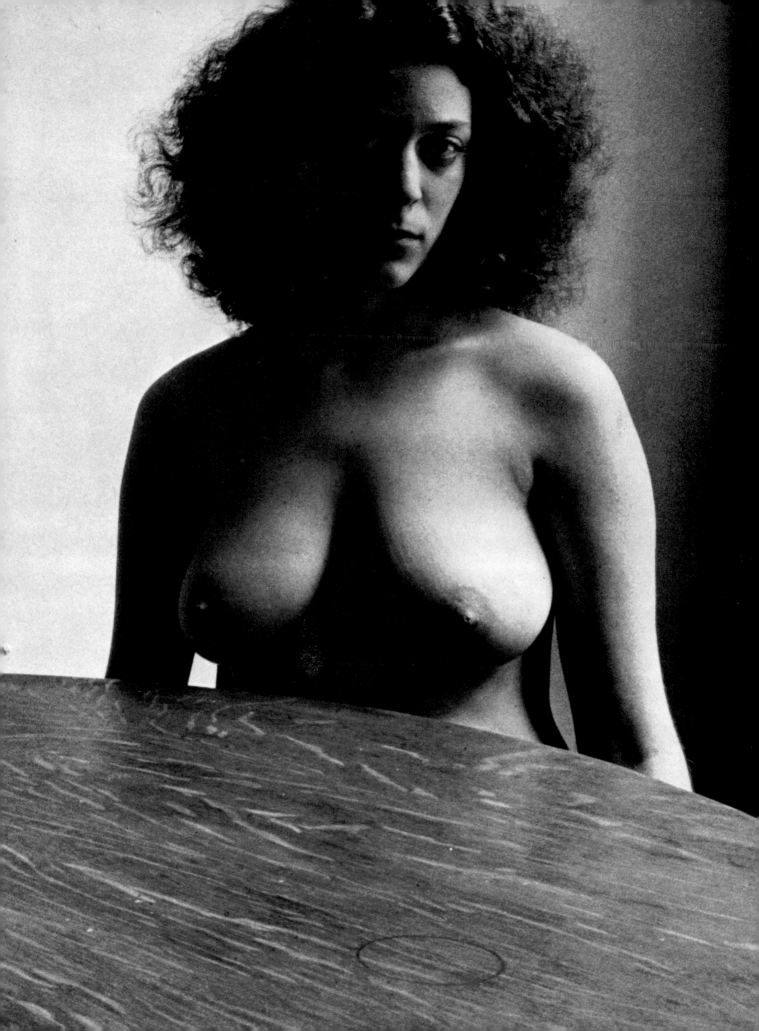

Michals borrowed a friend's apartment to shoot the sleight-of-hand in his newest sequence (next page) and was photographed in the act by Harry Wilks.

"Something Strange Is Happening."

The first time it happened, he decided that it hadn't happened. Yet, he did remember the sunlight reflecting on the knife as he set the table. A moment later, when he returned from the kitchen, the knife was not there.

That Thursday, he glanced into a mirror at work and saw that his tie was missing. That morning he had put on his favorite red tie. It was as if it had never been there.

All told, Michals has completed some 70 sequences. His newest, "Something Strange Is Happening," is shown here. It reflects an evolution in form from the *haiku* of his earlier work, which tended to be tightly framed on one stage, to the more diffuse literary mode complete with narration—

what Michals has called "illustrations for Alice in Wonderland."

The eight images weave together three of his recurring themes—the power of objects, a mysterious sense of loss and subtle intimations of death. (In the last frame, only the man's hands vanish, Michals points out—"making the whole

man vanish would have been too much like Walt Disney.") Like mirrors within mirrors, the pictures reflect Michals' own evolving view of the way things really are.

"I'm developing a very, very strange relationship with reality," he says. "I have an awareness of myself as a temporal being and the total

overwhelming mystery of my being. As I get older things fall apart more and more. I think it's some kind of growth but I find it frightening because I'm losing things out of my life that my ego can't account for. I don't take anything for granted anymore. The familiar is becoming unfamiliar."

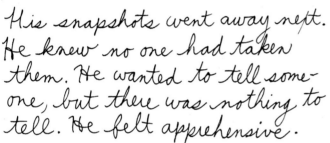

His snapshots went away next. He knew no one had taken them. He wanted to tell someone, but there was nothing to tell. He felt apprehensive.

Nothing in his past could help him explain what he was now experiencing. In some way these objects had defined his reality, and without them he felt diminished.

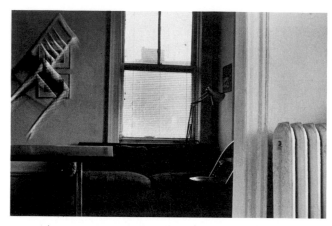

As he entered his apartment, he saw the chair behind his desk fly silently into the air and disintegrate. It became a sort of dust and was gone. He became sick:

He was not surprised to find his closet empty. Everything familiar was becoming unfamiliar. He could not be sure of anything.

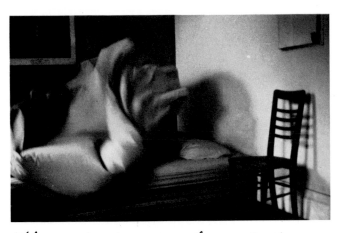

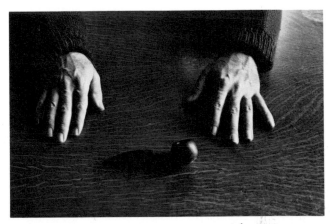

The sheets on his bed began to vibrate and swirled into nothing. He had ceased to be frightened and was now filled with a heavy calm. He began to wait.

There was a pipe on the table that he had never seen before. He did not smoke. For a long time he just sat looking at it. More and more the pipe felt familiar, as if it might have once belonged to him.

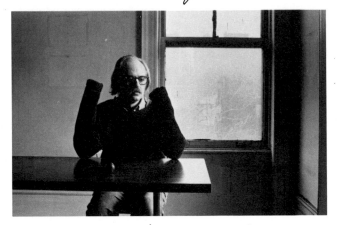

Without looking, he knew that his hands were gone. Everything was silence around him. He was becoming silence. He was going too.

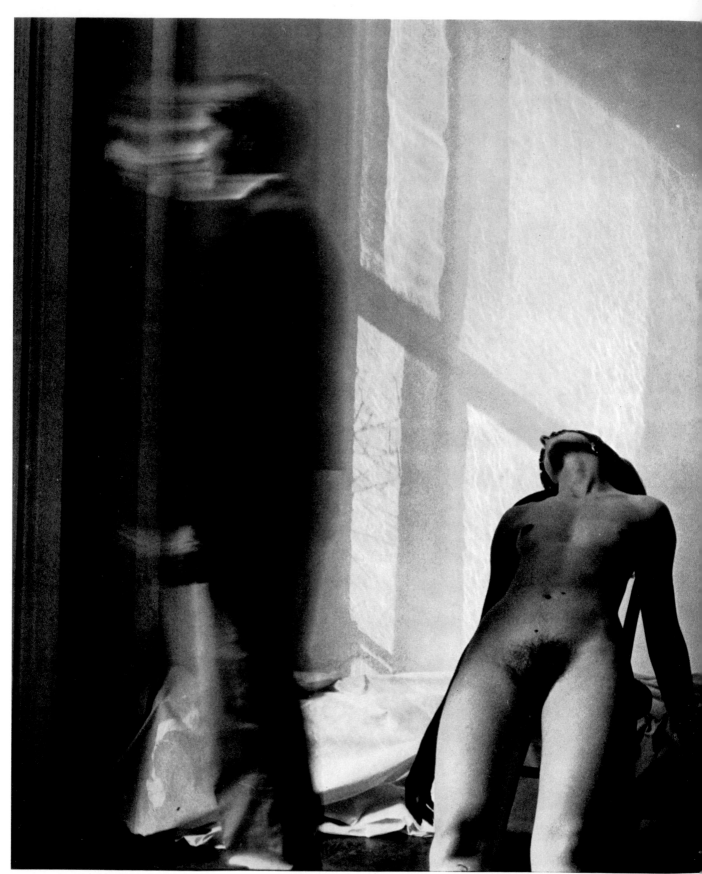

Single Images: Using light to create illusions

Despite the success of his sequences, Michals has not lost interest in the single image. It imposes upon him a tough discipline of technique and graphics, keeping him from flying off too far into abstraction. (So too does his wry and self-mocking sense of humor. "When you're very serious the way I am," he says, "you have to be very silly too. When I give talks I'll say something I think is terribly important, then make a terrible pun or swear where I usually don't swear. It defuses pretensions. You can't be too serious if you say 'fuck' at the end of a sentence.")

In the single image he must compress complex ideas into one instant and yet somehow transcend the moment. The photograph at left, for example, calls up both past and future by raising questions rather than answering them. Is the

A single image portrays Michals' view of the eternal enigma of man and woman.

girl dead or alive? Who is the man? Why is he walking away? Michals himself won't tell us, indeed says he doesn't know. He wants to suggest dramas, question human relationships, disjoint our sense of reality.

"Most photographers bore the hell out of me," he says. "They are just showing me versions of everything I've seen before. They don't question our preconceptions. What I look for in my own work and in other people's is not something esthetically satisfying but something to jar my sensibilities, throw my head off the trolley, something that says wait a minute. I want some-

thing that destroys our prejudices and preconceptions and makes us consider, for the first time maybe, just what the hell this thing is that we're in."

One such preconception that Michals seeks to destroy is the photographic myth of male-female relationships. He returns to the theme again and again with his camera, influenced perhaps by the difficulties in the relationship between his own mother and father. "When most photographers deal with male-female relationship," he says, "about 90 percent of the time they show screwing or tits or lovey-dovey. You

never see fights or hostility, the violence of relationships."

Michals' photographs often suggest eroticism but he wants to go beyond sex. He shows vanity and vulnerability and violence. In one of his sequences a man is turned into a coffee table; in another, entitled "People

Eat People," the man literally devours the woman, beginning with a loving nibble on the hand and finally leaving only her head.

He wanted the photograph below to suggest both vulnerability and violence. Viewed alone, the trussed-up nude might serve only to arouse curiosity. But the dim presence of the man at the half-opened door creates an intriguing tension. "There's a drama in what's happening," says Michals. "You can read a number of stories into it. I find the human body beautiful but I would never do a nude just standing there. I would never do closeups

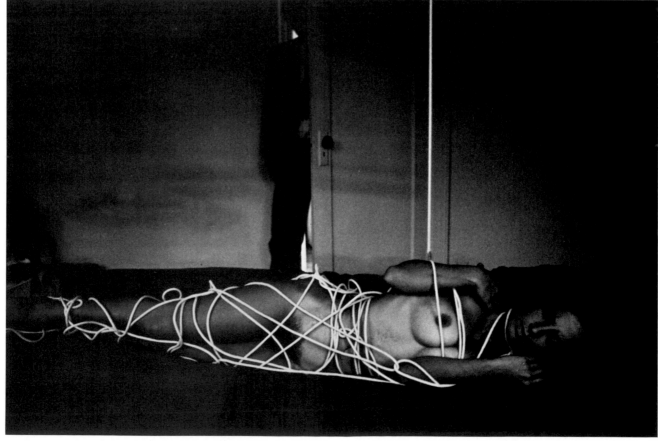

46

of elbows and breasts. I would find that boring. There has to be a tension—a presentation of an unresolved situation.''

This photograph also reveals a technical resourcefulness that Michals, in his preoccupation with content rather than packaging, seldom talks about. It was made at night, illuminated only by a street lamp outside the window. The room was so dark that Michals couldn't get a reading on his light meter. He shot from a tripod, opening up a 35mm lens all the way to f/2.8, and focused on the one thing he could see clearly, the white ropes binding the girl. He guessed at the exposure—about two seconds, which he counted off to himself since he wasn't wearing a watch. ''One of the marvelous things about film'' he says, ''is that if you expose it long enough you're going to get a picture.''

Michals is the bane of camera-magazine interviewers. He cares about camera gadgetry only to the extent that it enables him to communicate ideas, with about the same concern an author has for a typewriter. Told about a marvelous new lens, he recalls Tho-

Double exposures like this need careful pre-visualization.

reau's reaction when told a telegraph had been built that would link Maine and Texas: ''Yes, but does Maine have anything to say to Texas?''

He works only in 35mm, though his images are so meticulously composed that they appear to have been wrought on the ground glass of a view camera. ''I tried a 4x5 camera once,'' he remembers, ''and it was a disaster.'' He uses a Nikon single lens reflex and, for double exposures, an Argus C3, a discontinued amateur's camera similar to the one he borrowed for his Russian trip back in 1958. (He never bothers to read the technical columns in the camera magazines and only recently discovered that the Nikon F2, introduced in 1972, permits multiple exposures. He bought one but he also purchased three more Arguses—''for sentimental reasons''—after he heard they were becoming hard to find in second-hand camera shops.

What Michals likes most about cameras are the results that most photographers consider accidents. ''A camera will do marvelous things naturally,'' says Michals, ''not just the f/64 things.'' He likes blurs and double exposures

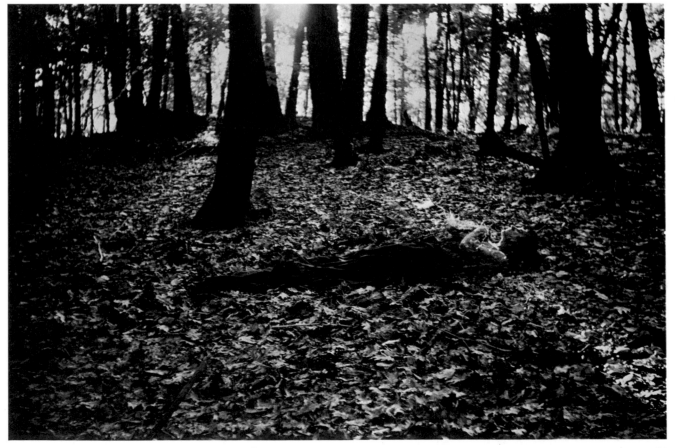

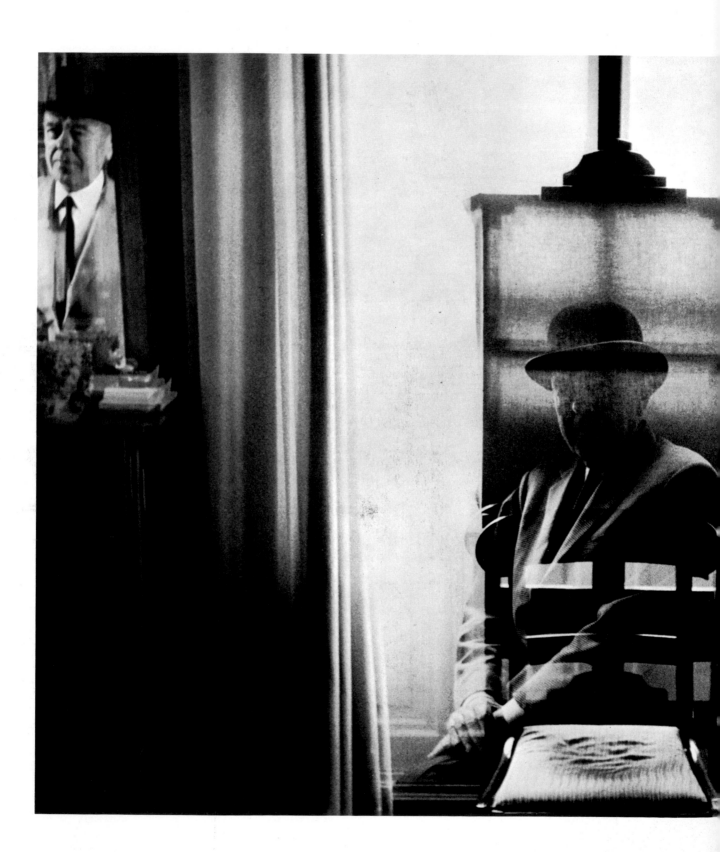

because they alter reality, and takes advantage of them much the way a painter uses the accidental thickness of his paint to change his composition. "People believe photographs in a way they don't believe paintings," he says. "You can actually have more impact in photography, especially if you're dealing with a very ordinary theme and suddenly you inject one thing that throws it off completely."

Michals made his first double exposure on the Russian trip as an accident—the Argus C3 lacks an automatic device for preventing it. He remembered the effect and used the multiple exposure in making visible his ideas about a subject that seems unphotographable—death. The photograph on page 47 was made for his longest sequence—published in 1971 as a book, *The Journey of the Spirit After Death*—but it can stand alone as a single image. Michals wanted the dead man, Danny, to appear as if he already were in the ground. He shot at dusk, working quickly to catch the fading light so it silhouetted the man. The scene was photographed twice on the same frame, once without the man, achieving an illusion of luminous leaves filtering through his vaporous body. The result is a magical image of a man buried but still in-

Surrealistic portrait of the surrealist painter, René Magritte.

explicably visible.

"I think death is the central issue," says Michals. "Everything else is a distraction. When I was 20 I felt I was immortal. Now I'm in the middle of life. I can see the whole thing."

For his vivid mistrust of surface reality, Michals owes much to the surrealist painters. From them, especially from the Belgian master René Magritte, he has borrowed techniques for subverting our preconceptions—surprise, incongruity, visual puns.

Magritte's paintings portray elements of everyday reality, but always include some contradiction or jolting dislocation of the familiar. In a still life of a table setting, the wine bottle becomes a woman's body. An ordinary pair of workman's boots sprout human toes. When rain falls on normal houses on a normal street, the raindrops consist of men in bowler hats. "Magritte was the first person who graphically challenged my preconceived notions about reality," recalls Michals. "Graphically, not intellectually, he shook me up and made me question things."

Much of Michals' work might be captioned with Magritte's credo, "One should not mistake the image for the reality." Certain photographs derive directly from Magritte's paintings. In one sequence, a hall tree sprouts feet, as in the Magritte boot. In another, entitled "Things are Queer," giant hairy

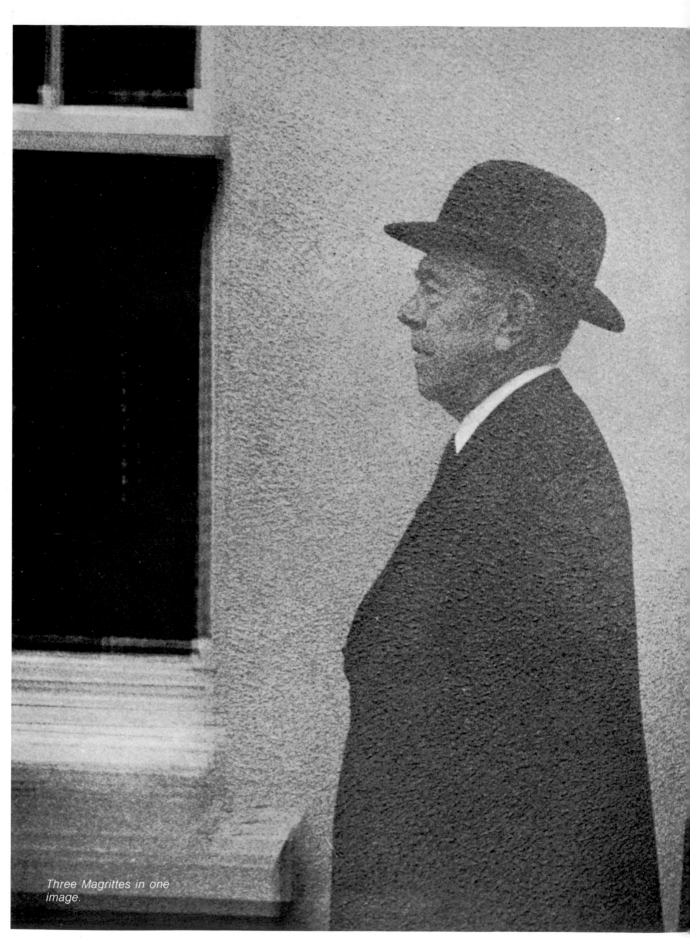

Three Magrittes in one
image.

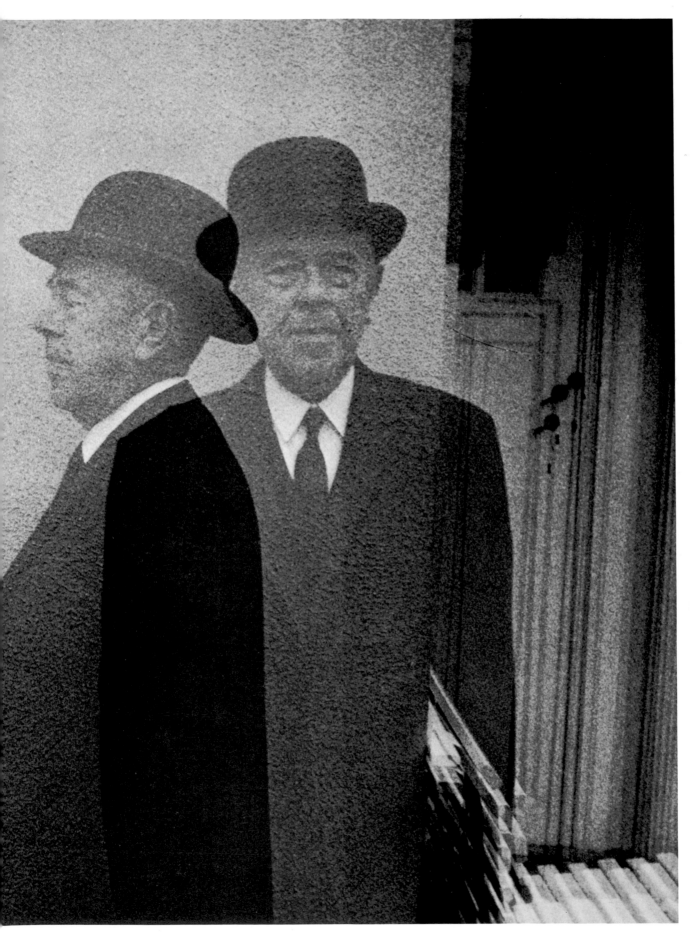

human feet dwarf an undersized bathroom commode—just as Magritte painted a pocket comb that dwarfed a bed.

But Michals paid his greatest homage to Magritte in 1965. He visited the master a couple of years before his death and created the photographs shown here (pages 48–51), mimicking the Magritte style to make portraits of him.

Typically, Michals' introduction to the artist was arranged by chance. At lunch one day a woman he had known at Parsons School of Design happened to mention that she knew a Frenchwoman who was

writing a book about Magritte. Soon Michals was in Brussels, visiting Magritte's studio every day, lunching with him, watching his home movies and photographing him. "I came back floating," recalls Michals, "and the joy was I could send back the pictures to thank him." Magritte's letter of thanks hangs framed on the wall of Michals' apartment, and sales of the photographs have paid for the trip.

One photograph (pages 48–49) resulted from one of his most successful uses of the double exposure. It was

the only frame Michals shot of the situation, which was styled after a Magritte work showing an easel and painting framed in a window against a "real" landscape. Working in Magritte's home, Michals first photographed an empty easel in front of the window. Then, on the same frame, he photographed Magritte sitting in a chair in front of the window and wearing the bowler hat portrayed so often in his paintings that it had become a kind of trademark. Because Magritte happened to be in the room when the first exposure was made, Michals earned an unplan-

ned extra—the artist's reflection in the mirror at the left of the photograph.

In the second photograph (pages 50–51), Magritte was exposed three times—once facing the camera and twice in profile. Michals had to hand-hold the camera because he didn't have a tripod with him, so there was slight camera movement between exposures. Michals would have preferred to maintain all three figures of Magritte at the same height. Nonetheless, the technical flaws accidentally achieved an extraordinary effect. The illusion of three doorknobs at

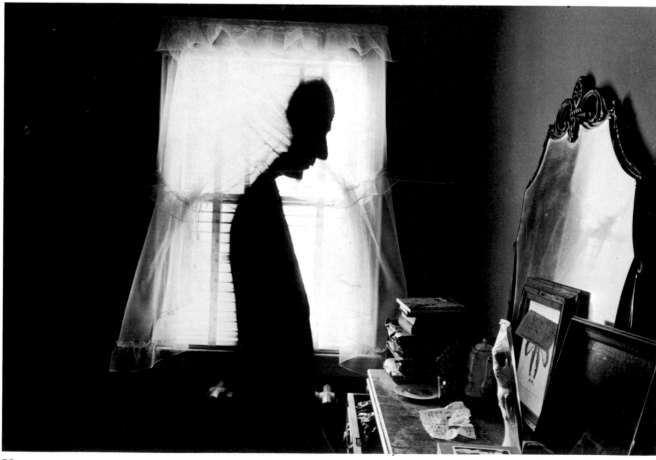

the right of the picture not only echoes the three Magrittes but corresponds to the three half moons in the original Magritte painting that inspired the photograph.

Michals feels the portraits not only pay homage to Magritte's style but leap beyond to reflect the photographer's own point of view. Although his work has been influenced in various ways by other painters including Balthus and de Chirico, and even by the authors William Blake and Lewis Carroll, he insists that each one has been a jumping-off place, not a hang-up. "A photog-

rapher should use influences," he says, "then drop them."

In 1971 Michals paid photographic tribute to another of his favorite artists, the late Joseph Cornell (at left). Michals visited Cornell's home in Long Island several times and found him "very difficult to work with, very vain, a very strange man." Ordinarily, Michals would work to attain a blurred image through careful control, asking his subject to move in front of the camera several times at varying speeds. In this instance, the subject couldn't be manipulated, but luck intervened. Mi-

chals was shooting at a slow shutter speed in the dimly lit bedroom when Cornell moved slightly, producing a dark sliver of an image silhouetted like a Giacometti sculpture against the proscenium window. Michals never showed him the portraits because he was afraid Cornell would dislike them, though the artist found Michals' other photographs interesting and used them in making collages.

The element that underlies all of Michals' photographic technique is his extraordinary understanding and use of available light. He abhors strobes and floodlamps

and resorts to them only rarely—and never in his personal work. He seldom works in direct sunshine because it causes harsh shadows, and prefers the subdued light of early morning or dusk if the picture has to be taken out of doors. Indoors, he looks for windows and even for mirrors and glass doors that will give back whatever light is there. "I'm like a moth," he says. "I always go to the light, and once I find good light I feel I can take any kind of picture."

In the photograph below, Michals was experimenting with light as a tool in portraiture.

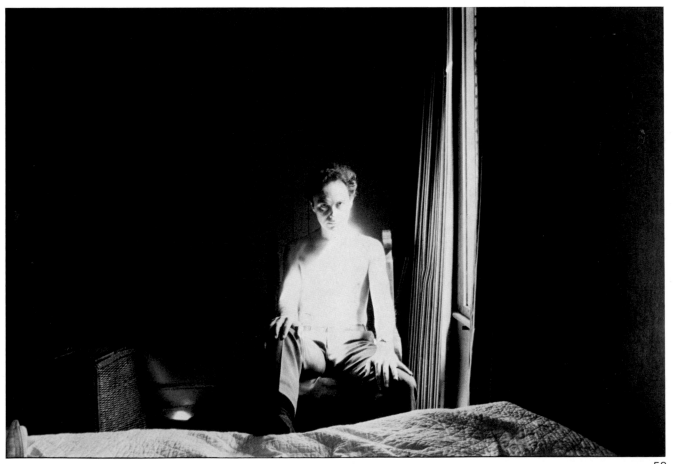

He sat an acquaintance in a stream of window-focused sunshine, then exposed for the dark lower part of his body so that the white T-shirt would bleach out, creating a mysterious luminosity. "I don't think photographers use light enough," says Michals. "Very few play with it in this way."

But, for Michals, light is more than a photographic tool. It pleases him esthetically. "For me, light is energy and energy is joy. My apartment disappoints me because it's dark." More important, light embodies a spiritual meaning that appeals to his long fascination with religion. Some of this interest stems from his boyhood days at Holy Trinity parish in McKeesport. "I did the whole number—choir boy, altar boy. Our priest was Father Duwell and I always thought that was a marvelous name for a priest. But I had to dump Catholicism to get back to the Christian idea. All those old notions have come back to me but now they mean something. Like when Christ says, 'I am the light'."

In recent years Michals has read extensively in Eastern religions, especially Buddhism, and since 1968 has been practicing daily meditation. He sits quietly for about 20 minutes, counting his own breath and attempting to "cut out all the noise, so that which we really are will make itself known. That's the hardest thing in the world—to stop the noise."

He points out that in most forms of Eastern mysticism "illumination means light or to lose your identity in the light, which is the truth." This concept led to the photograph on this page, which he calls "The Illuminated Man."

Michals had envisioned a shaft of light so intense that, on film, it would wipe out a man's head. One day, going uptown in a New York cab through the tunnel near Grand Central Station, he happened upon it. Overhead a chunk of concrete had been dislodged and the sun stabbed into the dark tunnel like a high-intensity spotlight.

He took a friend there on Sunday, when traffic was sparse, and posed him in a white shirt to reflect the light onto his face. He exposed for the tunnel darkness, then, in printing, burned in the

"The Illuminated Man," a Michals comment on the spiritual power of light.

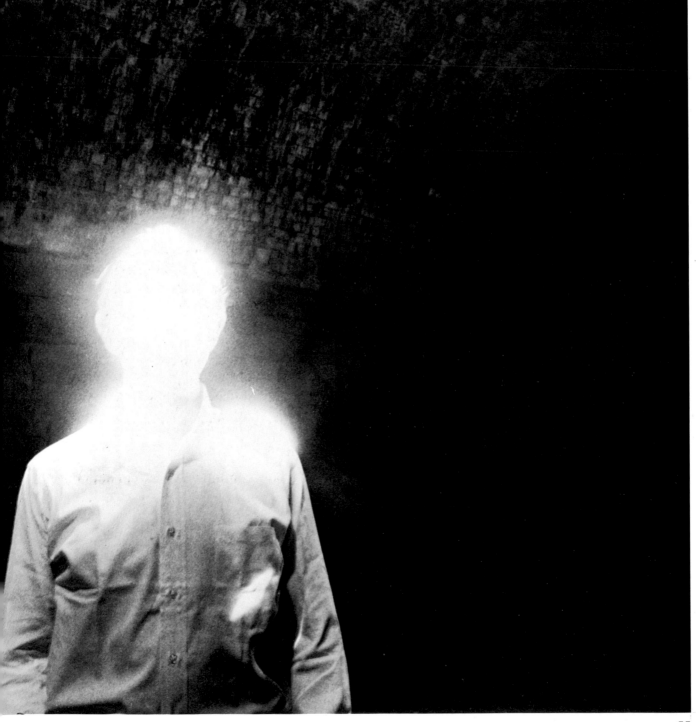

shirt, darkening it to make it clearly visible. He printed on high-contrast paper to enhance the grainy effect of a face disintegrating, an identity being lost in the light.

The hole in the tunnel ceiling was soon repaired, and that suited Michals' sense of the ephemeral nature of all things, including light. But an unnerving postscript to the picture occurred sometime later when he saw a new book of paintings by René Magritte. The cover painting bore an uncanny resemblance to Michals' ''Illuminated Man.''

Jobs: Portraits that tell a client's story

Michals sold his first photograph-as-art 15 years ago when he got $25 for one of his Russian pictures. Today a single image brings $185, a long sequence $800. But even higher prices and increased sales can provide only a fraction of the income of the photographer-artist.

Some of Michals' contemporaries teach. Others try to make do on foundation grants. Michals still makes his living by taking pictures on assignment—editorial work and even advertising—and he makes no apologies.

''I love doing jobs,'' he says. ''Some people get very heavy about serious photography. They say, how could you possibly do a job for money? I would take pictures for nothing and the fact is that people pay me to do it.''

Michals straddles with-

Author
Christopher Isherwood

out strain his two photographic worlds, one teeming with the workaday demands of commercial and editorial clients, the other a rarified realm of collectors and museums. The workaday world provides not only a comfortable income but the luxury of time during which Michals' personal ideas can bud and ripen. His personal work, in turn, furnishes tactics and techniques for shooting pictures on demand.

The two portraits shown below reflect one such carryover from the personal photographs of the preceding pages—his preoccupation with light.

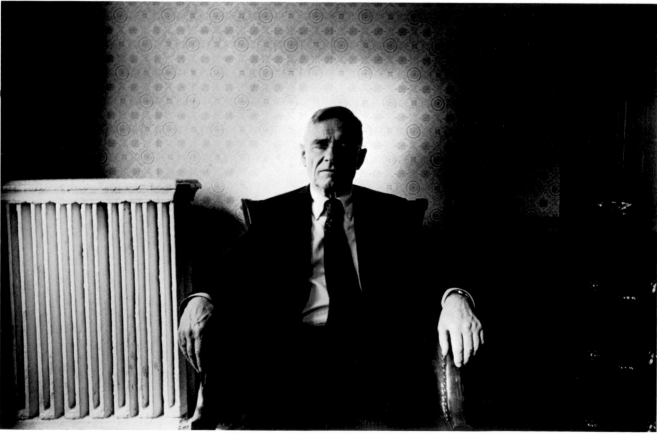

Photographing author Christopher Isherwood (at left) for *Vogue,* Michals saw him as a spiritual figure because of his writings on Eastern mysticism. He asked Isherwood to close his eyes for the portrait. Then, in the darkroom, Michals dodged in the bright halo—in effect, creating the light he wanted. In the case of Actor Robert Duvall (below), who was photographed for *Mademoiselle,* it was a matter of looking for the right light. Michals found it behind the ramp circling Grand Central Station. He stood Duvall against a stark metal plate so that the light would play boldly upon the actor's bald head, which was newly shaven for a movie role.

Most art directors like working with Michals —and not only because he produces masterful photographs. One reason is his Jesuitical sense of responsibility. "I don't just knock out anything," he says. "In the Depression when I was growing up, people had a great deal of respect for work, no matter what it was. They didn't look for esthetic pleasure as an end in itself. They were damn well glad if they were making five

Actor Robert Duvall

bucks a day. My father would walk to the steel mill five miles every day just to see if there was any work."

Michals still winces when he recalls the summer he worked in the same mill. One day he was thrust into the job of running a complicated pipe conveyor belt. "It was a nightmare. Pipe was falling all over the place. I must have ruined $5,000 worth of it. I still feel guilty. My grandfather worked in that same department and I know I shamed him."

Another reason for Michals' popularity among art directors is that his ego is not riding on

every assignment. Rare among freelances, he has his own personal work where no one tells him what to do, and is thus not offended if an editor doesn't like his idea or if an art director crops off an elbow. "There are photographers who put all their emotions into assignments," says Roger Schoening, *Mademoiselle*'s art director. "Often I don't need that kind of creative energy —it gets in the way. With Duane, there's no *sturm und drang* about it."

Michals has never bothered to hire an agent. He keeps his picture files in printing-

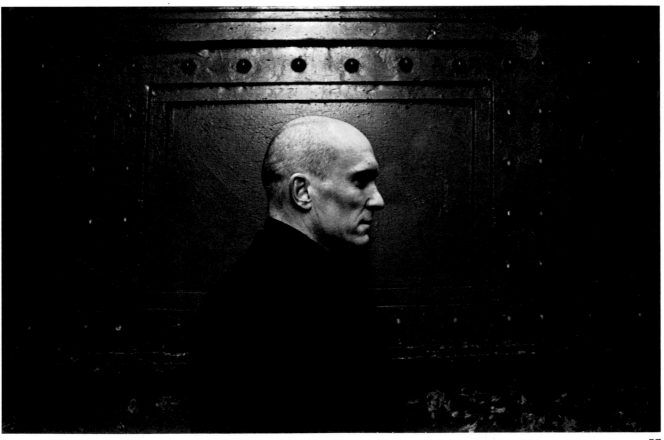

paper boxes stacked to the ceiling in his closet-like darkroom. He does his billing from a cluttered artist's easel in a cubicle of his apartment in the four-story brownstone that he and a friend bought several years ago. "Compared to a guy like Avedon,"

says Michals, "I'm just a cottage industry."

His approach to business hasn't changed much, in fact, since the early days when business depended largely on a chain of happenstance. His first paying

Actor Warren Beatty

assignment resulted from the accident that, vacationing in Mexico, he stayed in lodgings later rented by a young magazine illustrator. The man was Harvey Schmidt, then putting together an Off-Broadway musical, *The Fantasticks*. A mutual friend introduced

them and Michals was hired to shoot cast pictures to hang in the lobby for what became the longest-running musical in New York history. "I got $25 for each picture of the cast," says Michals. "Luckily there were enough turnovers in the cast to

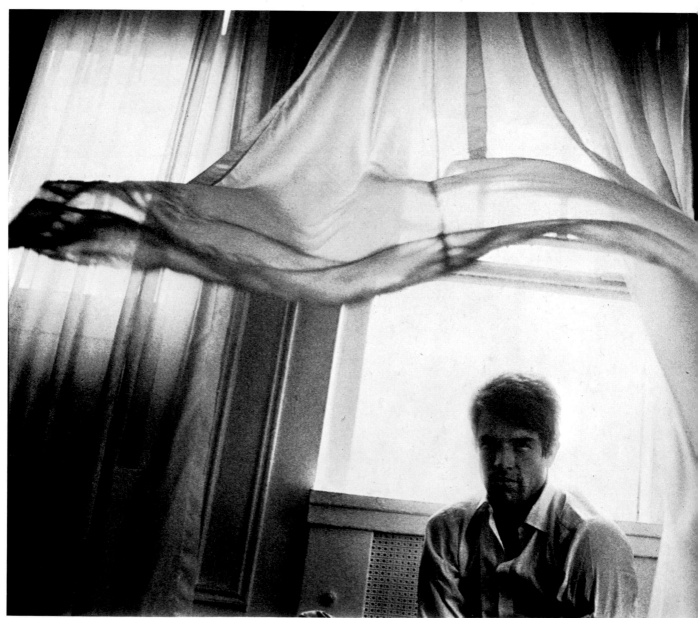

keep me going."

Michals already had a few contacts among art directors from his days as a designer. One was Henry Wolf, who had left *Harper's Bazaar* to design Huntington Hartford's new plaything, *Show.* Harvey Schmidt supplied additional con-tacts and so did another rising young man of the arts, who was painting Campbell soup cans in a downtown loft. Andy Warhol happened to be from McKeesport, though Michals had never known him there. They got together in New York in the late 1950's after a friend told Michals about this fellow McKeesporter who drew shoes for Bon-wit Teller advertisements.

Michals had lunch at Warhol's apartment—Scotch and salami, since that's what happened to be in the Warhol refrig-erator that day. Later, when he decided to go into business with his camera, he photo-graphed Warhol to aug-ment his meager portfo-lio. Warhol gave him some names of people to see, and some good advice: Blow up portfolio pictures to 16x20 so art directors will remember them. In addition, Warhol gave him a few pieces of his work. Michals didn't like them and gave them away. He later wrote rue-fully in a caption for a Warhol photograph, "One should never give gifts away."

From the beginning, Michals has been most in demand for his por-traits of well-known peo-ple. Most of his subjects are in-a-hurry celebrities, so in a matter of 15 or 20 minutes he must find a way of seeing them that will satisfy him and his art director. "You never can capture a per-son in a picture, never," he says. "You might get an interesting expression or gesture. I almost never research a picture subject ahead of time. I think Karsh is full of ba-loney. Can you imagine spending a whole week out in La Jolla with Jonas Salk soaking up his ambience, then wind up making him look as if he's in the studio in Ot-tawa with his thumb under his chin?"

Often Michals has to work against the dull ar-chitecture of New York hotel rooms, making use of his feeling for inani-mate objects. One day, for example, he was waiting in a hotel room to photograph actor War-ren Beatty for a *Made-moiselle* story on Beatty's movie *Bonnie and Clyde.* A waiter came bringing drinks, and Michals noticed that when he opened the door the sudden draft stirred the window cur-tains. Michals left the door open and made a portrait of Beatty that suggests the presence of some invisible force more than a mere wind (shown at left).

Actor David Hemmings

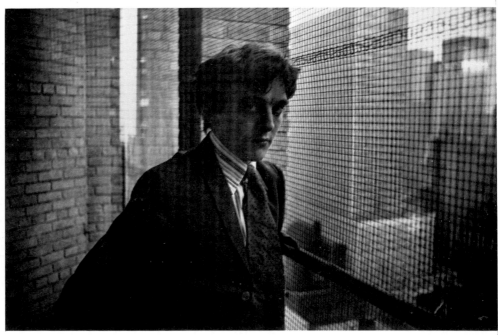

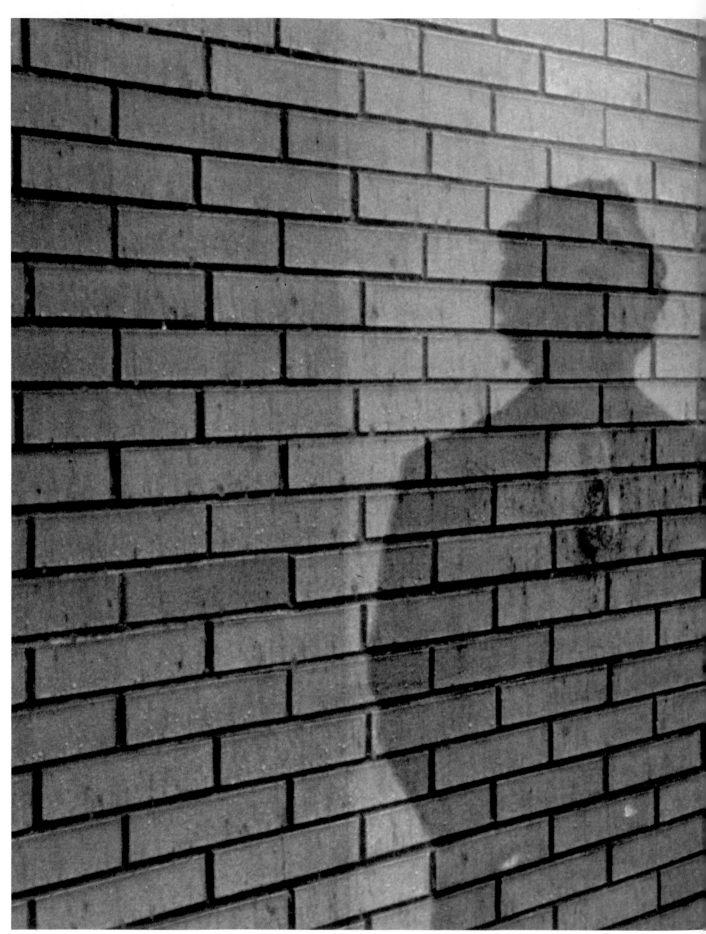

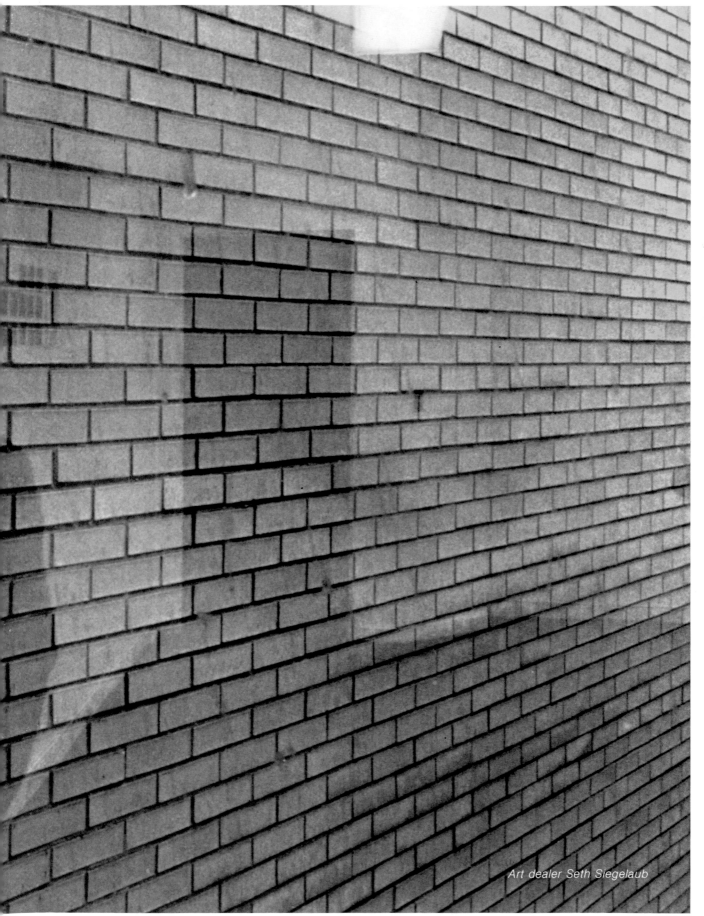

Art dealer Seth Siegelaub

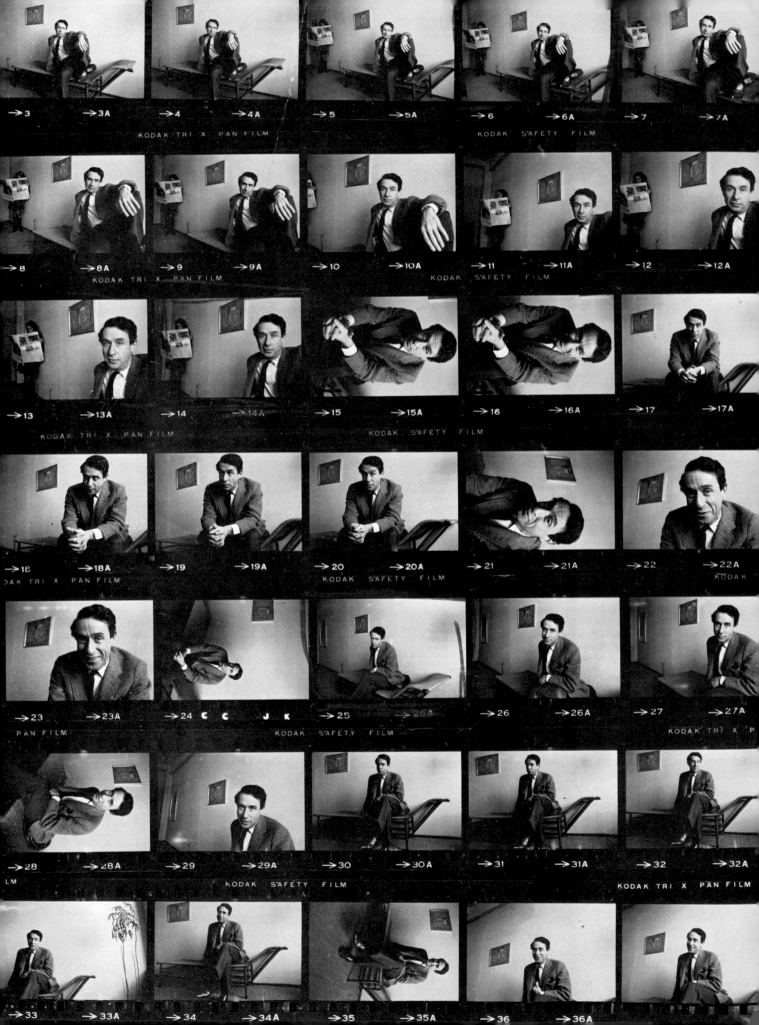

When all else fails, Michals may resort to mirrors or glass doors to reflect another reality. One evening at dusk he was stalking about the hotel room of British actor David Hemmings, stuck for an idea. Then he opened the glass door to the L-shaped balcony and saw that the door not only permitted a view of the protective wire mesh outside, it also reflected it. He shot through the door so that Hemmings was laced through with a stark geometric web reinforced by the brick wall and by the skyscrapers reflecting the dying sun (page 59).

On assignment Michals carries around in his head, the way other photographers carry a case of strobes and a shoulder bag full of gadgets, a cerebral arsenal brimming with ideas. He is constantly trying out new tactics for making pictures that look at people in a new way. One experimental portrait of photographer Harry Wilks consisted of segments—separate close-ups of his ear, mouth, hands and toes.

"I like portraits that don't necessarily show what people look like but have to do with what they are about," says Michals. His portrait of art dealer Seth Siegelaub (pages 60–61) shows only the man's shadowy reflection. The photograph was made inside a room with a large window, which mirrors

Siegelaub in such a way that he appears to be no more than a shadow cast upon the brick wall outside. The image perfectly suited Siegelaub's elusive identity. A gallery operator without a gallery, he dealt in conceptual art—staged events that were later described on paper—and rented a room when he wanted to display the documentation.

One difficult assignment for *Mademoiselle*

involved photographing a variety of moviemakers. Michals liked the notion of putting foreign directors in a very American setting, so he posed Marguerite Duras in a New York subway car. He found Dennis Hopper in a smoke-filled room and got a portrait that was appropriately dream-like.

As always, he shot with great economy, seldom using more than two or three rolls for a

portrait. His contact sheet of Arthur Penn, reproduced at left, illustrates Michals' elegantly precise approach. He was working within severe limits—one man, one room (Penn's office) and one lens (the 35mm wide-angle). "There wasn't much choice," says Michals. "There was just one area in the office where the light was good, and I liked the shape of the sofa there. I don't make a lot

THE MOVIEMAKERS

FIFTEEN OF THEM, HOME-BASED FROM U.S.A. TO SENEGAL. INTERNATIONAL SCENE
BY LEO LERMAN

CASSAVETES

His *Shadows* (1960) helped set the international moviemaking real-reel style. *Faces* (1968) zipped director-writer Cassavetes right into the moviemaking empyrean; *Rosemary's Baby* did it for actor Cassavetes. In *Husbands*, he does all three of his genius things. "The picture is all personal. Who would do a film if it wasn't personal emotions and experiences? To hell with ideas and words. No one listens, anyway. The only thing people care about today is what they feel...." Next acting: *Mickey and Nickey*; directing, etc.: *Opening Night*.

HOPPER

Easy Rider (Dennis Hopper directed, co-authored, acted, co-produced) cinched the lived movie: camera-in-hand, shoot-as-it-really-is, film-as-you-hear-them-rap kind. Here is ugly-time U.S.A., a Whitmanesque hymnation bitterly in reverse. "Movies," says Hopper, "are finally getting to where it is. When they get where it *really* is, the audience gets there to see it. The kids know.... Now that *Easy Rider*'s making it, a lot of smart (maybe brilliant) new film-makers will be able to find out if they are brilliant." Coming: *The Last Movie, The Second Chance*.

PENN

For over a decade, Arthur Penn's been in a state of film/theatre experiment. A main Penn preoccupation: violence—that men do to themselves, to one another. Basic Penn technique: enchant the eye while honing the flick with spoof, satire to a scalpel in the moviegoer's heart. Recent examples: *Bonnie and Clyde, Alice's Restaurant*.... "Young people," says Penn, "are different ... marvelous ... original ... have courage...." Also: "I decided not to be bothered with the big studios again. I hate Hollywood...." His next, *Little Big Man*.

DUANE MICHALS

69

of small talk. I usually go in and pretty much pry out of people what I want.''

Michals likes the wide-angle lens because it enables him to include something of the subject's working milieu. In Penn's office it broadened the picture's interest by taking in a happenstance—a young woman in the corner reading a newspaper, unaware she was in the photograph. Michals liked the situation and shot 10 frames before concentrating on Penn alone.

The editors' choice for publication was frame 26, apparently because of Penn's quizzical expression. ''You're selling photographs and you have to please yourself,'' says Michals. ''But essentially you have to please somebody else. Of course, I'm unhappy if they don't pick the picture I like or if they crop it. But you can't be prima-donnaish about it.''

T

The photographing of two moviemakers together—Paul Mazursky and Larry Tucker, who had collaborated on *Bob & Carol & Ted & Alice*—presented a different sort of challenge. Michals was intrigued by the vividly contrasting body shapes of the two men—the rotund Mazursky, the slim Tucker—and he decided to show them ''disassociated, like two objects in space.''

It was a bright sunny day, so Michals sought out a softly lit sidestreet where he found the architecture to control his composition—a subway entrance. The contact sheet on the right shows the different elements Michals used in separating his two subjects—an iron railing, the stairway and, in the picture selected for publication, the post marking the subway entrance.

''I like to walk down the street with a subject and bounce off what I see,'' says Michals. ''It's difficult because you have to be looking, talking and judging the light all at the same time. You operate on several levels —like when you're driving a car and carrying on a conversation with a passenger. But some subjects are very easy to be with. They're delighted when they find out you're going to play around a little and not just do the standard look-at-the-lens picture.''

But Michals has no illusions about his celebrity subjects. ''They're usually very charming because they want you to take a good picture,'' he says. ''I used to be taken in by it. I would think, isn't that marvelous, Kim Novak thinks I'm terrific. Two minutes later, she couldn't care less.''

In recent years Michals has successfully undertaken other kinds of magazine assignments

THE MOVIEMAKERS CONTINUED

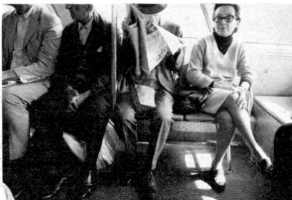

DURAS

Postwar France's sharpest woman pens are Beauvoir, Sagan, Marguerite Duras. Duras wrote *Hiroshima, Mon Amour*; Tony Richardson, other yesterday's-tomorrow moviemakers flicked her multileveled *romans*. Now she's lensed her own: *Destroy, She Said*. Duras says: ''Let's stop making films for everyone. Let's make the films we want to make. If these films address themselves to everyone, that is really not up to you to decide. Stop submitting to the world in which you live: judge it. Stop submitting to the films offered to you: judge them.''

ATTENBOROUGH

Actor Richard Attenborough (*I'm All Right, Jack*; *The Great Escape*, many long-run West End theatricals), movie producer R. A. (*The L-Shaped Room, Seance on a Wet Afternoon*—also acted in it) is, with his constellated, all-sing-right-out-loud-for-peace *Oh! What a Lovely War* (first he's directed), on top and way above it. He says: ''The cinema is a director's medium, and if one feels that there is something one wishes to say, some plea one wishes to make, then the only way to achieve it, with any degree of satisfaction, is by directing yourself.''

MAZURSKY, TUCKER

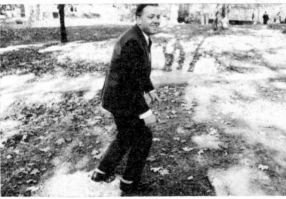

Chicago's *Second City* prepped Paul Mazursky (center), Larry Tucker (right), in the cut-them-up-while-you-make-them-laugh technique. P. M. directs, co-writes with L. T. (also produces) so closely that they make up a single new movie thrust. Big breakthrough: *Bob & Carol & Ted & Alice*. Say Mazursky-Tucker: ''It's the most exciting time ever. Easier for creative film-makers to get backing. . . . Our future plans . . . another original, same top team . . . *Alex in Wonderland*. Then *Oedipus Wrecks*, story of 50 dropouts who start a new society.''

72

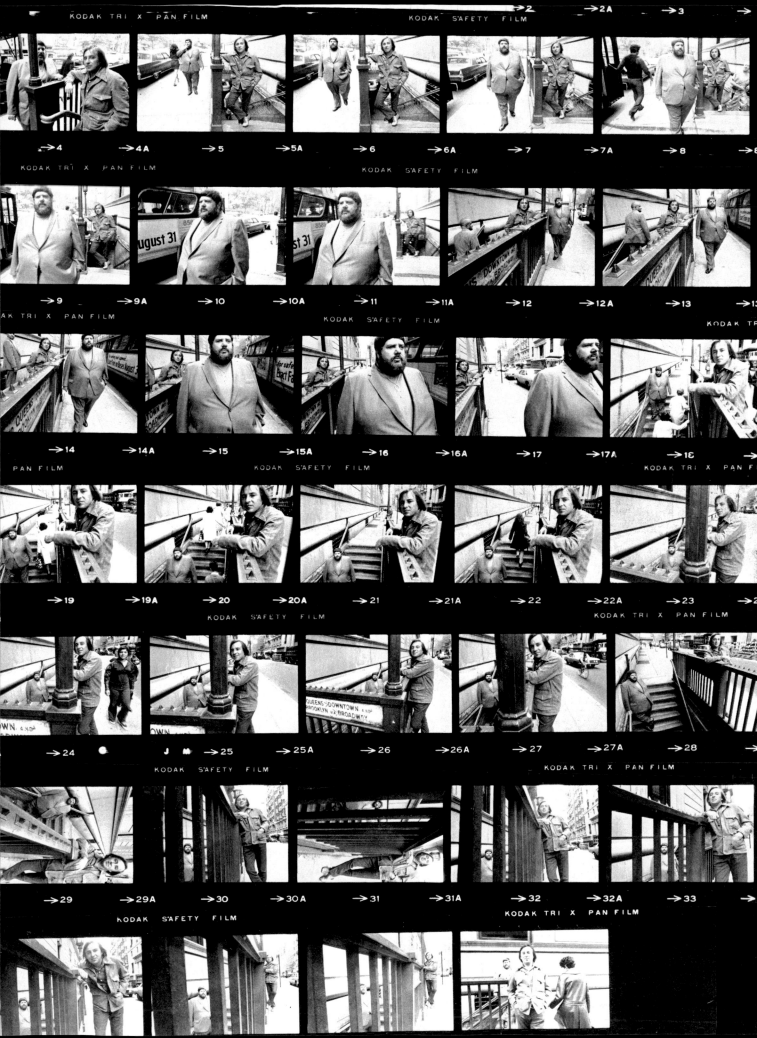

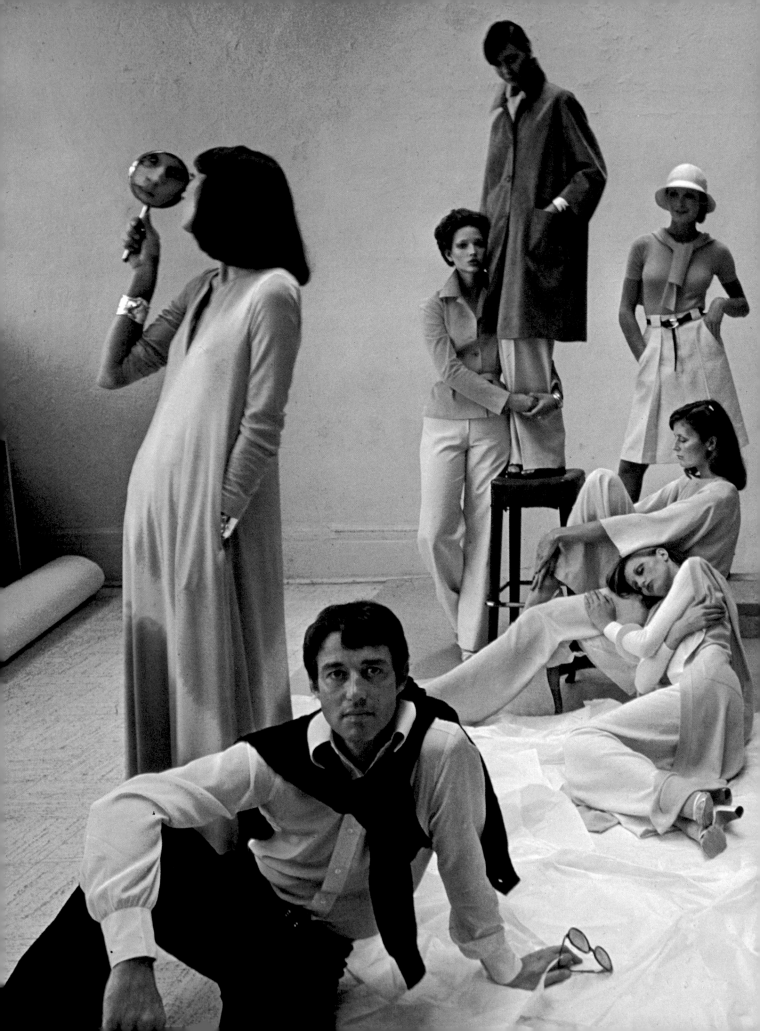

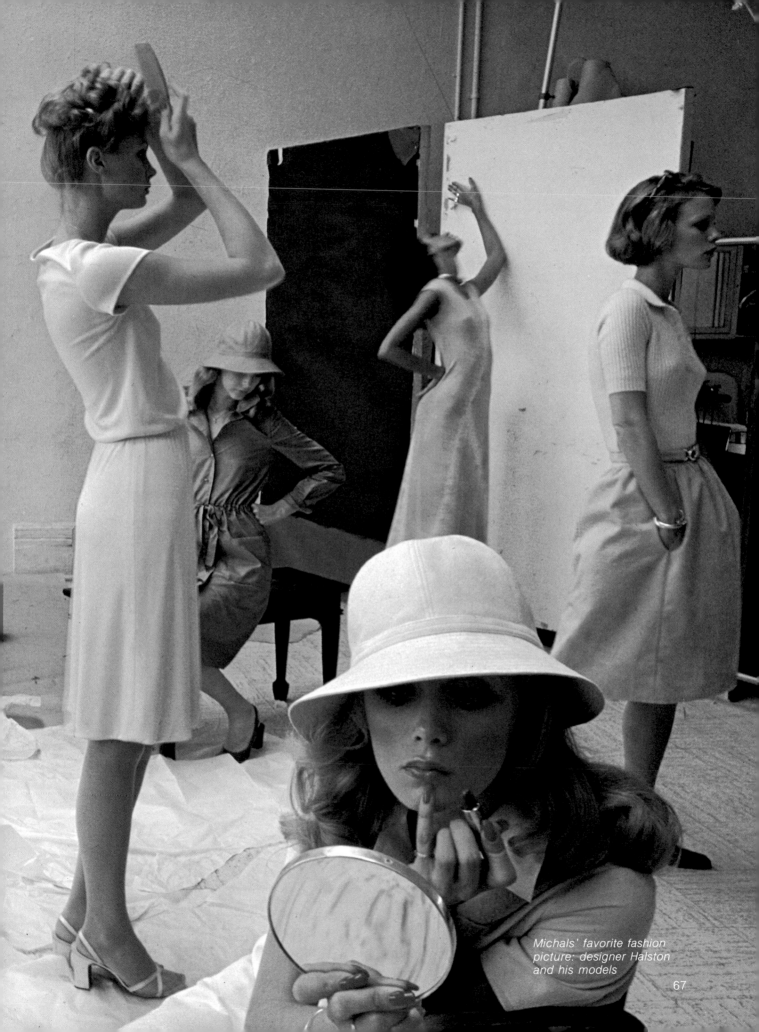

Michals' favorite fashion picture: designer Halston and his models

—room interiors, table settings and even fashion.

His casual, improvised approach often produces remarkably slick, commercial-looking pictures. If need be, he even overlooks his distaste for artificial lighting. To dramatize a cluster of cocktail glasses, he set them on a glass table and lit the scene dramatically from underneath with a floodlamp. Mastering such stocks-in-trade of the big studio photographers gives him a perverse delight, like an impish kid with a new toy.

At his best, however, he brings to such assignments the unconventional notions and techniques that distinguish his personality portraits. The strikingly different fashion photograph on pages 66–67, showing the designer Halston with a group of his models, was shot during an assignment for *Vogue*.

Before the shooting, Michals was told, "Don't worry about the clothes." But when the models and the entourage of hair stylists and editors arrived at the rented studio in Carnegie Hall, it was clear that the clothes were an important concern. Nonetheless, Michals decided to work with only natural light, from a few windows at the side and a big overhead skylight.

First, Michals shot "something I knew they would use"—a crisp, head-on view of Halston and his girls, which *Vogue* did indeed publish. "It looked so professional," he recalls. "It looked as if I did all sorts of hot stuff—light fills and everything." Then he made a picture for himself—Halston calmly facing the camera amid a multi-ring circus of models unconcerned with the lens but absorbed in themselves and their mirrors.

"I don't want to be a fashion photographer," says Michals. "I'm not interested in clothes to begin with and I'm not interested in that kind of world. It drives me crazy. The stylists are all running around and the girls want to spend a couple of hours on their eyebrows. By the time they're ready, you're done in from worrying about whether the light's going to go. And no matter how you cut it, no matter how clever you are, you're still selling the dress. I just wouldn't devote my life to ladies jumping in front of no-seam paper."

Michals' amiability in accepting assignments sometimes takes him into a world even more foreign to him than fashion—hurry-up photojournalism. Sent by *Esquire* to New Orleans to photograph the businessman wrongly accused in the assassination of President Kennedy, he was at least able to get Clay Shaw to sit still for a number of portraits in his plant-framed courtyard. (The picture *Esquire* used is at left, opposite a more revealing view of Shaw's vulnerability.)

So here you are, Clay Shaw, twenty months and thousands of dollars after being charged with conspiracy in the worst crime of the century. What are you doing about it?

Surviving
by James Kirkwood

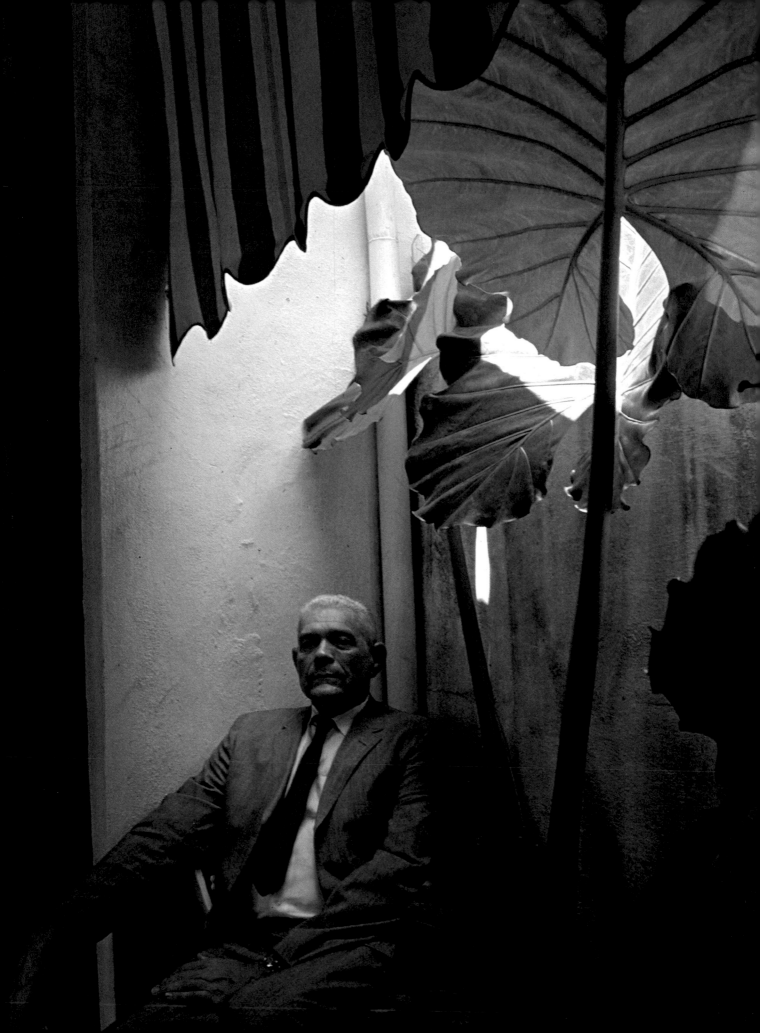

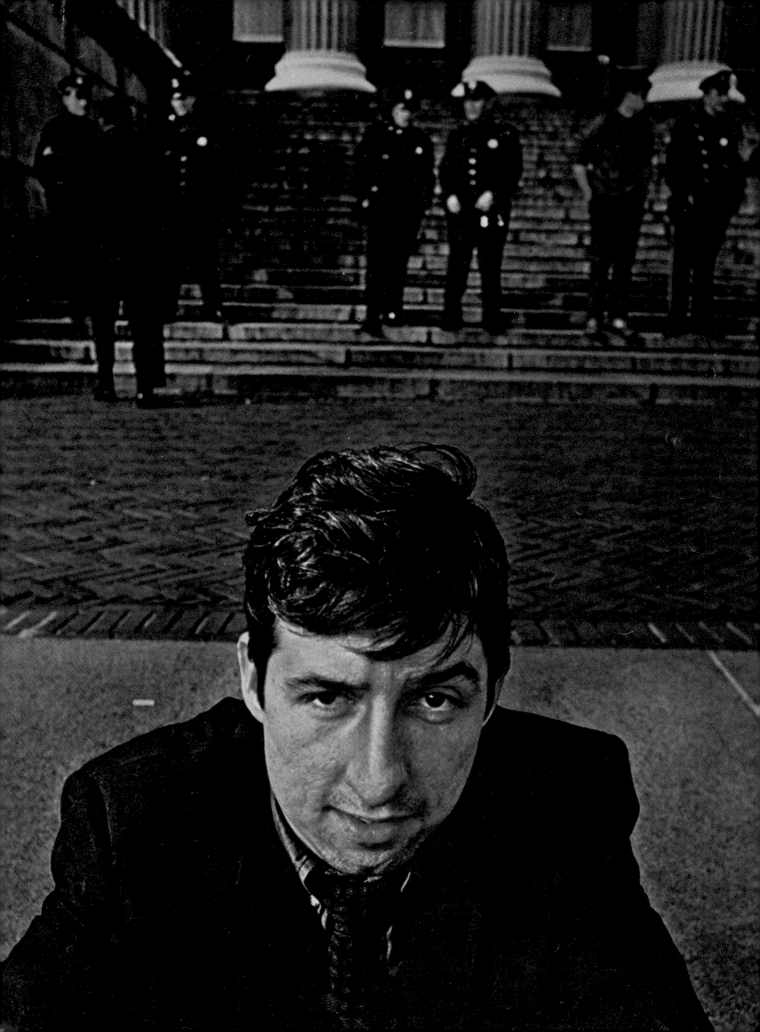

But for his daringly apt portrait of New Left leader Tom Hayden at left, Michals literally had to shoot on the run. Hayden was a fugitive, wanted for questioning in connection with the student riots that had just shaken Columbia University. The campus was full of police and Michals had only about 15 minutes with Hayden. He kept nudging the worried fugitive to a spot in front of the campus library. There, using a wide-angle lens and hand-holding the camera (a tripod would have called attention to the unusual portrait session), Michals was able to frame Hayden in the foreground against a phalanx of New York's unsuspecting finest.

Michals is the first to admit that his versatility ·is limited by his unique point of view. He recalls a series of New York scenes done for the *New York Times* promotion department. Michals was assigned along with one of his favorite photographers, Robert Frank. "The series was very reportage-y" says Michals, "the kind of thing Frank does with great ease and great style. I killed myself trying to get that kind of looseness, to get the absolute essential part of the event which he caught so well."

Tom Hayden

Most of all, he prefers portraiture, especially when one of the tricks in his cerebral bag perfectly fits the personality. He used a combination of the sequence and blurred movement, for example, to capture the nebulous personality of his friend Andy Warhol

"Most portraits are lies," he says. "They have nothing to do with the person at all. Certain photographers do a trip, chewing the person up in the process. I think Avedon, for instance, is a very beautiful photographer but I must say I would be very nervous if he wanted to photograph me. Some of his pictures —the book *Observations,* for example— catch people off guard. I think photographers have a responsibility to consider. There should be a subtle manipulation but you don't have to knock the viewer over the head with a baseball bat."

In his portrait of pop artist Claes Oldenburg (pages 10–11), Michals tried out another idea inspired by his own personal work: destroying reality and reconstructing it in another way. Michals, on assignment for *Horizon,* borrowed a magnifying glass from Oldenburg and asked him to hold it in front of his face. The picture grossly enlarged the subject's eyes and nose, but the distortion portrayed the truth of Oldenburg's sculpture, which grotesquely magnifies the size of such everyday objects such as a lipstick or hamburger.

Michals often talks as if he prefers ideas to people in the flesh but he has a flair for creating poignant human feelings in his photographs. This is most evident, ironically, in a series of national magazine advertisements for the pharmaceuticals manufacturer, Eli Lilly and Company. Each ad suggests a tender family relationship between a youngster and a much older person, a bridge across the generations, though none of the subjects are actually related.

The Geer-Dubois ad agency hired Michals for the campaign because of his museum reputation —to the delight of the photographer, who sometimes worries that agencies will think he is too serious to undertake such assignments. Together with Jim Adair, the campaign art director, he undertook the difficult preliminary job of

casting subjects for each ad. For a couple of the ads, he drafted neighbors of a friend who has a farm in upstate New York. For another, Adair contributed his daughter, Francesca, and their neighborhood butcher. The elderly woman in the ad on the next page was found at a senior citizens' center in New York; the boy was the brother of a youngster Adair and Michals encountered on the street. (A master at persuading people to pose, Michals once cast a carpenter acquaintance and his family for an *Esquire* sequence illustrating a short story about murder and incest.)

Michals usually shot the ad in the youngster's home, so the child would feel comfortable. He used sidelighting from windows and tried to select a background texture, perhaps a bit of wallpaper, that would make clear it was a real home and not a studio.

Michals' toughest challenge in shooting the 15 ads was to attain a variety of visual relationships within the tight frame of the 85mm lens. Adair wanted the subjects to look quietly thoughtful, rather than happy or active. Slow shutter speed also necessitated a stillness: Michals insisted on using Kodachrome 25 for its color quality, so he had to use a tripod

and expose the film for a full second. ''At the same time,'' notes Adair, ''we didn't want them to look despondent or sick. After all, these are ads for a drug company.''

The light sometimes dictated the relative positions of the two figures. For the picture on page 73, Michals used his own apartment and sat his building superintendent facing the front window because he wanted light on his dark face. Michals told the little girl to rest her cheek on the man's back—to silhouette her braid—and to look at the camera so her eyes would be highlighted.

''I think these pictures show that it's possible for anyone to go into his own home and take some very lovely things —if you look for light and know how to use it,'' says Michals. ''If you're dealing with people who aren't used to being photographed and you bring in big strobes and 20 assistants and 3

72

hairdressers, how can you possibly get them to relax? But if you're very easygoing, working in their living room and manipulating them slowly, it comes off."

Occasionally Michals' quaint disregard for the trappings of photography will disconcert the client. "He's so damn casual," says Jim Adair, recalling the time Michals was assigned to photograph IBM's top executives for an ad. "He had on that old canvas shoulder bag with a couple of lenses knocking around in it and he had his film in one of those plastic bags from the Peerless camera store. His Nikon was so old the black was all worn off." Finally, an IBM aide turned to Adair and asked nervously: "Gee, does he only have one camera?"

In fact, Michals carries *two* cameras, one of them a backup. He owns five different lenses —a 28, 35, 50, 85 and 105mm—but hasn't used the 105 since buying it in the early days to photograph opera performances for *Opera News.*

"The photographic act is not that difficult," says Michals. "But photographers tend to make a production out of it. A client is paying $500 or $1000, so they want to make him feel he's getting his money's worth."

Michals' first major ad campaign, for *Scientific American,* began in 1966 when he was still relatively unknown. Milton Ackoff, the freelance art director on the campaign, heard about him through another photographer's agent. By then, Michals had set aside his showcase 16x20 prints and carried his portfolio in a small box. Inside were five smaller boxes, each a different color and organized by subject—the Russian pictures in a red box, of course, personalities and so on. "Suddenly in came this sweet little gentleman with a little box under his arm," recalls Ackoff. "I'd never seen anyone present his pictures on such a modest scale. I liked him right off."

The idea of the campaign, which ran some 70 ads in *The New York Times* over 5 years, was novel for its time: showing scientifically-oriented executives, all of them subscribers to *Scientific American,* not at their desks but in the milieu of their favorite avocation. Michals photographed a gourmet in his kitchen, a

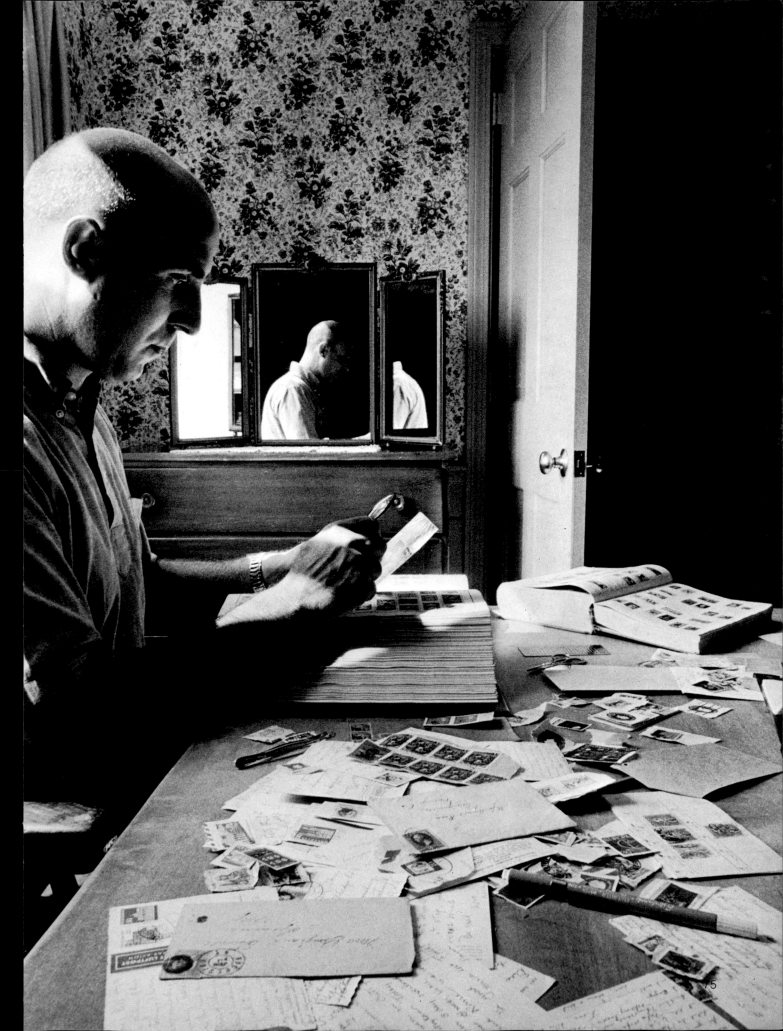

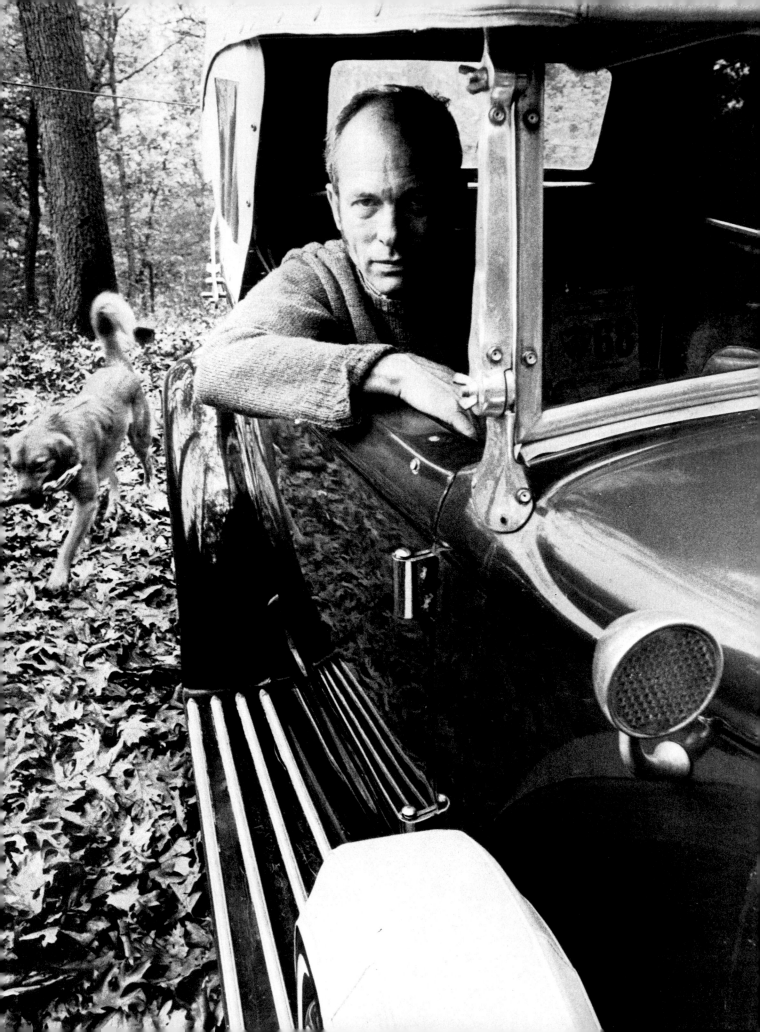

fisherman with his prize catch wrapped in newspaper comics, an antique car buff in one of his old autos (at left). ''I loved the challenge of going into a situation and absolutely not knowing what I was going to find there,'' says Michals. ''An executive would tell the magazine's research people that he had a marvelous Shakespearean library. Milt and I would go there and the guy would have like three books.''

The vice president of a steel company played the piano but Michals felt the light and setting were boring. So he shot through a window, letting the reflection of his tripod and own bald head show for effect (at right).

Another executive was a stamp collector, whose expensive modern home didn't appeal to Michals, who prefers old houses with tacky furniture— ''you know—the kind your grandmother had.'' Michals found the feeling he wanted in an attic room above the garage and, over objections from the stamp collector's wife, got him to pose there. The contact sheet on page 74 shows how Michals homed in on the final picture he wanted—with the man's profile reflected in a mirror Michals had placed there, next to a door he had opened to suggest a hallway.

Simon Feigenbaum is Chief Industrial Engineer of Jones & Laughlin Steel. Why should he care about The Sexual Life of a Mosquito?

SCIENTIFIC AMERICAN

"Sometimes I'm too ingratiating, too gentle," says Michals. "I'm too concerned that a subject might be uncomfortable or afraid I'm asking him to do something that might violate how he feels. It would probably be better for me to just say, look, get your ass over here. But I'm just not pushy in that way. I'm pushy in a soft way."

Rare among the breed, Michals is an avowedly happy photographer. He works about half the time on assignment, the rest on his own personal pictures. He can maintain his equilibrium even on an assignment, such as covering the filming of *The Great Gatsby* for *Vogue,* that casts him in the unlikeliest of roles—stalking stars Robert Redford and Mia Farrow along with the rest of the *paparazzi*—and come back with exquisite color (pages 78–80). He earns enough to live comfortably but not ostentatiously. "With any effort at all I could probably double my income," he says. "But I want to keep things as they are."

By choice, he has few close friends and seldom socializes, attending perhaps two or three dinner parties a year. He reads, gardens, cooks—and thinks full-time. "It's funny the traps people get themselves into," he says. "They don't really ask themselves, what do I want. We all make choices—I'm lucky because I feel I've made the right ones. A lot of people go through life out of register with themselves. I'm in register. I'm doing exactly what I should be doing."

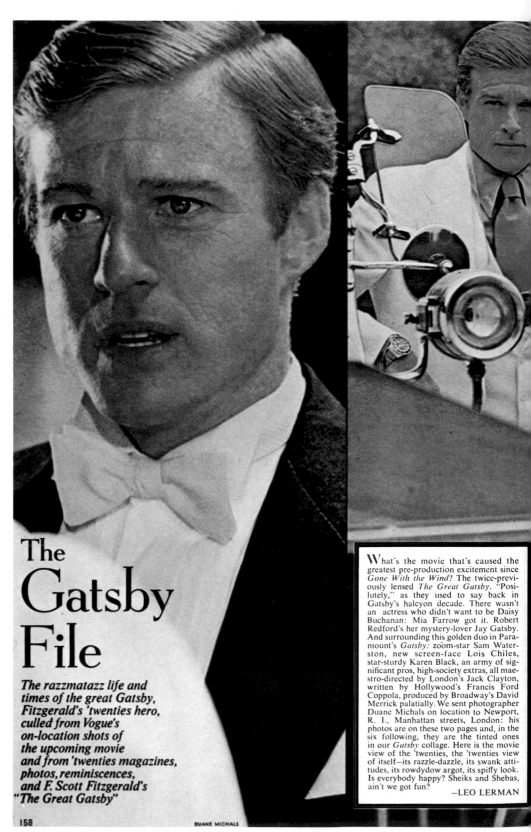

The Gatsby File

The razzmatazz life and times of the great Gatsby, Fitzgerald's 'twenties hero, culled from Vogue's on-location shots of the upcoming movie and from 'twenties magazines, photos, reminiscences, and F. Scott Fitzgerald's "The Great Gatsby"

158

DUANE MICHALS

What's the movie that's caused the greatest pre-production excitement since *Gone With the Wind*? The twice-previously lensed *The Great Gatsby.* "Positively," as they used to say back in Gatsby's halcyon decade. There wasn't an actress who didn't want to be Daisy Buchanan: Mia Farrow got it. Robert Redford's her mystery-lover Jay Gatsby. And surrounding this golden duo in Paramount's *Gatsby:* zoom-star Sam Waterston, new screen-face Lois Chiles, star-sturdy Karen Black, an army of significant pros, high-society extras, all maestro-directed by London's Jack Clayton, written by Hollywood's Francis Ford Coppola, produced by Broadway's David Merrick palatially. We sent photographer Duane Michals on location to Newport, R. I., Manhattan streets, London: his photos are on these two pages and, in the six following, they are the tinted ones in our *Gatsby* collage. Here is the movie view of the 'twenties, the 'twenties view of itself—its razzle-dazzle, its swank attitudes, its rowdydow argot, its spiffy look. Is everybody happy? Sheiks and Shebas, ain't we got fun?

—LEO LERMAN

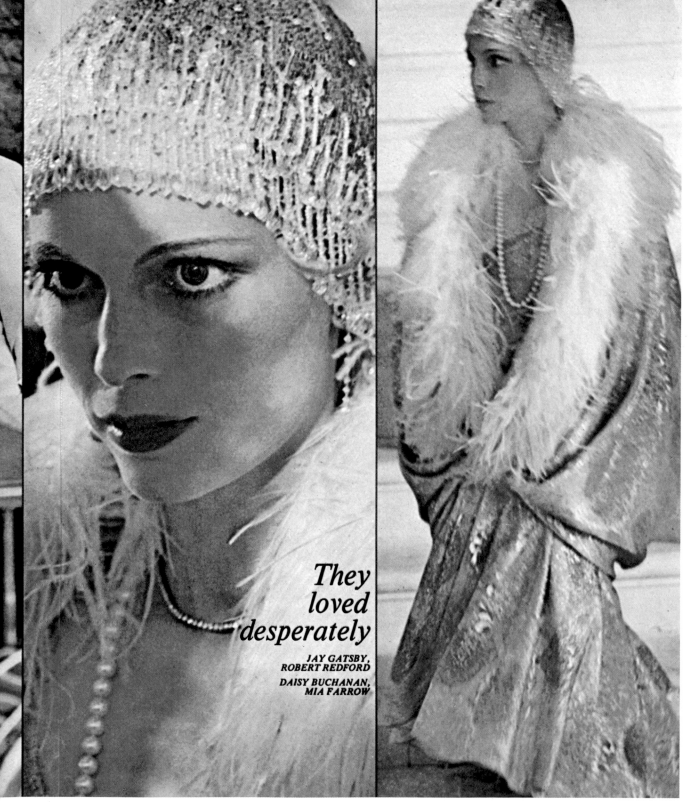

They loved desperately

**JAY GATSBY,
ROBERT REDFORD**

**DAISY BUCHANAN,
MIA FARROW**

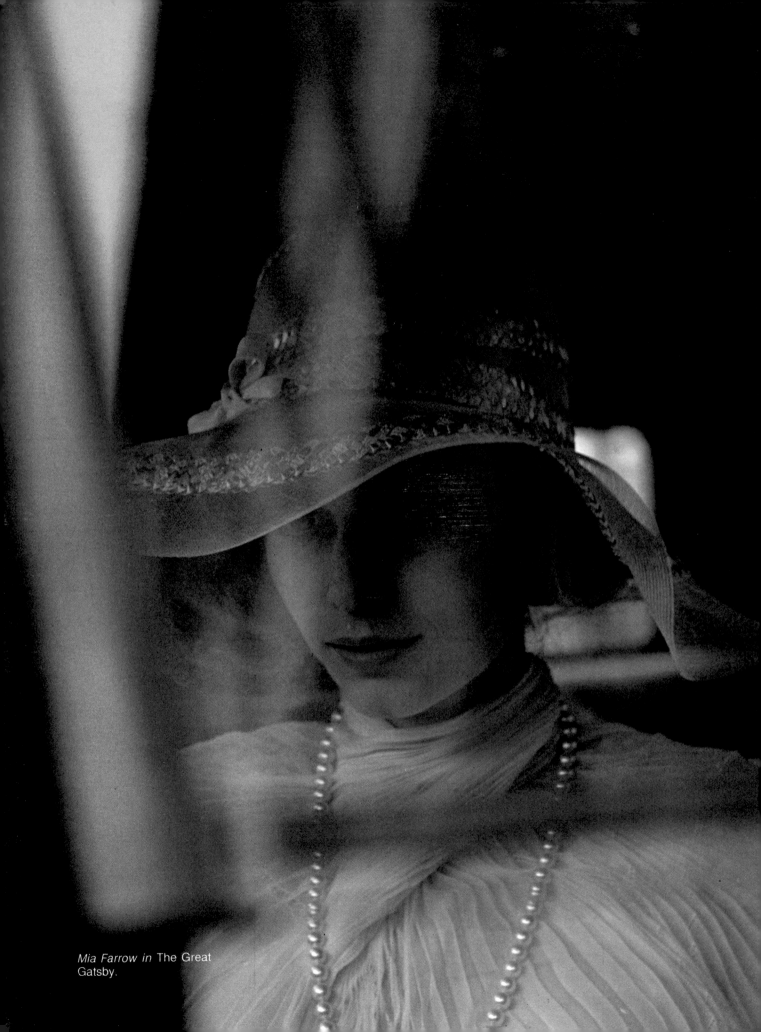

Mia Farrow in The Great Gatsby.

Technical section

Illusion and mystery are both difficult subjects in photography because the medium is so literal. There's a maxim in photo classes: "If you can see it you can photograph it." But the reverse, "If you *can't* see it, you *can* still conceive and photograph it," is also true, though it is not often explored. Besides being a seemingly relaxed master of portraiture and of interpretive photography for various publications, Duane Michals is an explorer and experimenter in camera and darkroom illusions.

At first glance, some of Michals' pictures are spooky, and it is easy to mistake the manner in which they were achieved. Are the multiple exposures created in a darkroom or within the camera? Did he use neutral density filters, mirrors, large cameras with trick boxes in front of the lens or some other esoteric means to place shadowy figures communing with themselves? Or does Michals have access to a master darkroom technician who is able to extract some magic from photo papers, developers and enlargers?

In reality, Duane Michals' technique is fairly simple, except for certain darkroom manipulations that anyone can learn. It is reassuring to know the following:

1. He almost always uses natural light (usually daylight), doesn't own an electronic flash unit, and says he wouldn't know how to use one if he did. "It's a basic awareness of light, and knowing how to use light well, that's all," he says with disarming simplicity.

2. He does not use a battery of custom-made cameras with trick lenses or other equipment not available to anyone with a sliding-scale budget. In fact, many of his multiple exposures are taken with a vintage 35mm Argus C3 camera that uses a rangefinder to focus, has a 50mm f/3.5 non-interchangeable lens and shutter speeds from 1/10 to 1/300 sec. It listed for $45.00 brand-new in a 1942 directory of photo equipment, and the Argus C2 without built-in flash synchronization sold for a mere $39.75 at that time. Optical quality of the Argus lens is good but doesn't match present-day equipment. As you will see however, the Argus has one special qualification that no current 35mm camera offers: Film advance and shutter cock are separate, which means you can cock the shutter any number of times for multiple exposures on one frame of film that stays precisely in place behind the lens.

3. Michals uses popular films such as Tri-X, Kodachrome and Ektachrome, all developed normally. "I don't think in my whole life I've ever pushed film speed," he says, and while this is not a practice for everyone, it is easy to understand his technique.

Having eliminated special equipment or materials as part of the explanation behind Duane Michals' photographs, we still need to know how he did go about creating illusion and mystery. There *are* techniques to be explained, but primarily, imagination and perception are the sources of his success—what the great realist photographer Edward Weston called, years ago, "Good seeing." The same can be said for the decisive-moment approach that photojournalists bring to their work, and in contrast, for the careful vision and preconception process demonstrated by an unusual professional such as Duane Michals. He "sees" single and multiple images first in his mind's eye and translates them onto film in quite explainable steps.

Just as Michals expresses his own feelings in sequences or single images, he conceives portraits in utter simplicity (Arthur Penn, page 62) or else with surrounding symbols that help characterize and tell a story (the stamp collector, page 74). Since he always uses natural light and settings, his style of direct but introspective portraiture can be emulated by anyone who cares to try.

Instead of looking for plain or innocuous backgrounds all the time, pose your subjects in the midst of their own environments. The sitter should usually dominate the scene, but the background or props can be photographed with a sense of design so that material which is ordinarily "clutter" becomes an integral, visual support to the portrait. You have to be selective so that the surroundings don't overpower the subject. And you will probably have to be persuasive, because most people will exclaim, "With all that junk around me?" Tell them you're trying some experiments. Show them a few of Duane Michals' pictures, and maybe they'll empathize with your attempts to reach out for new effects.

EQUIPMENT: THE VIRTUES OF SIMPLICITY

Duane Michals has always been a 35mm man, except for the one disastrous occasion he mentioned when art director Henry Wolf asked him to shoot with a 4x5 camera. View cameras, of which the 4x5 is one size, are heavy and use film holders that accommodate one piece of film at a time, so they are most appropriate for static situations in which you want to manipulate film within the camera (*e.g.,* multiple exposures) and develop it with special chemicals or techniques. Photography students are often required to use a view camera just to learn its discipline, architectural photographers favor it to correct perspective distortion, and studio photographers may find a 4x5 or even an 8x10 camera handy for exacting still-life pictures that a client wants on large color film for easy viewing, retouching, or gigantic reproduction.

The closest 35mm equivalent to a view camera, and the choice of an overwhelming number of amateurs and professionals including Duane Michals, is the single-lens reflex (SLR) camera. Looking through the lens of an SLR (via mirror and prism), you see precisely the image the film will register. Michals' kind of visualizing requires through-the-lens viewing, which is also apt for the average photographer because no matter what lens is mounted on the camera, what you see is what you get.

By contrast there are a few 35mm models that focus through a rangefinder—a separate opening in the camera body that doubles as a viewing window. The rangefinder's similarity to a view camera is less pronounced than the SLR's. You need a separate snap-on finder for extreme wide-angle or telephoto lenses even though the internal finder of a rangefinder camera may adjust itself to certain mid-range

SLR SYSTEM

RANGEFINDER SYSTEM

lenses. With a rangefinder however, you can focus conveniently in lower light levels than with an SLR, so the rangefinder camera has been a popular tool of photojournalists who often work in what is ironically called "available darkness."

Michals switched to an SLR, the Nikon F, about 1964, but stayed with the Argus C3 for multiple exposures. A few years ago he discovered the newer model Nikon F2 which allows you to cock the shutter *without* advancing the film (by depressing the rewind button on the bottom plate first). To avail himself of various lenses and shutter speeds before the Nikon F2, Michals had the famous camera-repair artist Marty Forscher in New York City alter a Nikkormat camera to double expose. "But it didn't work consistently for me," says Michals, "so I ended up falling back on the Argus. Now I have the Nikon F2, and I'm sitting pretty with its controls, lenses and double exposure ability."

DEPTH OF FIELD

In the beginning Michals used only the 50mm lens that comes as standard equipment on most 35mm cameras. After a friend introduced him to the broader field of view that a 35mm lens affords, he began to add to his small supply of equipment—first a 35mm lens and a 28mm, "which I thought was really fantastic." Today he swings back and forth between 50mm, 35mm and 28mm, and for portraits he often uses an 85mm lens. Many of his sequences are done in small rooms, so the wide-angle lenses give him depth of field in a limited setting.

It is an optical principle that the shorter the focal length of a lens, the more inherent depth of field it offers at any given f/stop. *Depth of field,* of course, is the distance between the nearest and farthest objects that appear in sharp focus on a print or slide (or in the finder of a camera with the lens stopped down).

Depth of field is the product of three factors:

Aperture: The smaller the lens opening, the greater the depth of field, whatever the focal length of a lens. There's a depth of field scale on the lens barrel of all single-lens reflex cameras (either 35mm or larger format), and depth of field tables are printed in books or instruction manuals for most lenses used on 35mm cameras.

Focal length of the lens: As mentioned before, a lens of short focal length, *i.e.,* a wide-angle lens, has greater depth of field at any given aperture than a normal 50mm lens or a telephoto such as the 105mm or 135mm. Therefore, if you must shoot in places where the light level is low, and can get close enough to photograph a subject with a 35mm lens, you can keep more in focus from foreground to background at wide apertures such as f/2.8 or f/4 than if you use a lens of longer focal length at the same f/stop.

Focusing distance: The closer you focus to a scene or person, the less depth of field any lens produces at a given aperture. The reverse also holds true, so focus set at a greater distance from an object means depth of field will increase if the lens opening stays constant. Set at 5 feet, a 50mm lens at f/8 offers sharp focus from 4 feet 4 inches to 5 feet 11 inches, but if the same lens is focused at 10 feet (still at f/8), the depth of field covers everything between 7 feet 6 inches and 14 feet 9 inches—more than a quadruple increase.

The visual effect of perspective, and the ability to work in restricted areas, are also assets offered by wide-angle lenses—and Duane Michals has skillfully taken advantage of both. Note in the proof prints on page 65 how he uses receding lines, or think about the expanse of a room he achieved along with a relatively large image

of Arthur Penn on page 62. The person reading the newspaper in the top three rows of proofs didn't know she was in the photograph, and this, Michals states, "is one of the joys of a wide-angle lens."

For his kind of photography, Michals sticks almost exclusively with lenses of the four focal lengths mentioned. This in no way denigrates the value of telephoto or zoom lenses for the rest of us, but they don't fit into his personal approach. "I don't feel photographers should be hung up on equipment," he says. "You should know how to use your camera completely, how long you can hand-hold exposures, and all the limits to which you can push. The camera should function without your even thinking about it—so that the point is always the photograph. Exposure should not be a problem, either. The camera is a machine, and I love what it does, but I'm not enamored of *it.* I don't read camera magazines, and when people ask what I think of a so-and-so model camera, I usually have to say, 'What's that?'

"On an assignment I always take two cameras, the second one as a backup. I take two or three lenses, depending on the job." Although you may have seen pictures of photojournalists weighted down with cameras and lenses draped over neck and shoulders, it is not unusual for a professional to limit equipment to accommodate his or her personal vision.

HOW LENS OPENINGS AFFECT DEPTH OF FIELD

50mm F2

50mm F4

50mm F8

HOW SUBJECT DISTANCE AFFECTS DEPTH OF FIELD

<3½'

7'

20'

HOW FOCAL LENGTH AFFECTS DEPTH OF FIELD

135mm Lens

50mm Lens

24mm Lens

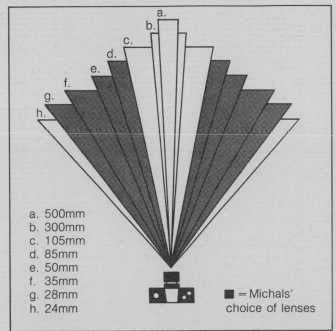

a. 500mm
b. 300mm
c. 105mm
d. 85mm
e. 50mm
f. 35mm
g. 28mm
h. 24mm

■ = Michals'
choice of lenses

Duane Michals uses one other piece of equipment regularly, a Tiltall tripod, made of aluminum, weighing about 5¾ pounds, and listing (in early 1975) for about $82. There are a number of versatile tripods on the market from a variety of manufacturers; the main factor to consider in selecting one is *stability*. Though some lightweight tripods (two or three pounds) *seem* to hold a 35mm camera steady, many are not stable enough to be trusted for multiple exposures during which the camera must not move at all. It takes weight and precise construction to make a tripod stable, and investment in an excellent tripod pays off in confidence while you shoot for now and the indefinite future.

MAKING MULTIPLE EXPOSURES

Michals used the simple Argus C3 for many years because he could make one exposure on top of another on a single frame of film with the assurance that the images would be in perfect register. The film did not shift even one millimeter when the shutter was re-cocked for a second exposure. If you have ever tried to make a double exposure with a camera designed to *prevent* it from oc-

curring accidentally, you know how difficult it can be. However, it *is* feasible, and the method for doing it is described here.

1. Double the ASA film rating on the proper camera dial. In other words, if you use a film rated at ASA 25, set the dial for ASA 50 if you plan to make two exposures on a single frame of film. In this way, each time the shutter clicks you get half the proper exposure, and two images superimposed will give you a slide or negative of the correct density and color saturation. Should you be making three shots on one frame, triple the ASA rating. Thus ASA 25 becomes ASA 75 or whatever figure is closest to that.

True to his idiosyncratic approach, Duane Michals says he does not follow the technique just described. "I just take an exposure reading the way I want to take the shot," he explains, "and expose it at that. Since I'm making a double exposure, of course the film gets twice the amount of light as one shot would give it, which means it should be overexposed, but I like my negatives overexposed about a stop. They're actually not too dense, and I never have problems printing them. It's probably not the right way to

do it, but it's my way and it works for me."

Chances are that he hedges a little in computing multiple exposures as part of the personal "way" he wants to take the shot. Since he uses this technique for black and white, and makes his own prints, he has refined the process to tolerable limits that suit his own taste. You might want to try the Michals way as an experiment and compare it with the results you get when you do halve the exposure time. Overexposed or underexposed black and white negatives certainly offer latitude for compensation during the printing process. With color, however, slides will be too light—"washed out"—unless you double the ASA rating of the film, and this condition cannot be corrected.

2. Turn the film takeup knob until the film is tightly wound within the cartridge. Removing the slack helps maintain proper registry of images.

3. Make your first exposure, keeping in mind the main elements of the composition.

4. Depress the rewind button or "clutch" usually found in the bottom plate of a 35mm camera. This allows you to cock the shutter without advancing the film.

5. While holding the takeup knob firmly to prevent the film from shifting, cock the shutter a second time. Make your second exposure. At this point, no matter how painstaking you have been, your film does not stay in one place if you make a series of multiple exposures. Frame lines shift slightly off register, and when this happens with color film, some processing labs will return slides to you unmounted because they won't risk cutting the film arbitrarily. In that case, edit and mount the images yourself.

6. Cock the shutter again in the usual way and repeat the process. You can avoid off-register problems to some extent if you shoot only one or two multiple exposures,

return to singles (even if you have to leave blanks), and then shoot doubles again.

7. When you make single exposures, remember to reset the ASA film speed to the correct rating.

Study Michals' results and experiment with planning your own multiple images to achieve impact. Light subjects against dark ones tend to show up well. Two light subjects placed in the same area will wash each other out. Two dark subjects overlapped will usually be satisfactory if there are some bright contrasts within them.

Unless your mind's eye is as well tuned as that of Duane Michals, double exposing includes a large serendipity factor. But you don't have to depend entirely on luck. Taking chances, trying to plan carefully, and cocking the shutter slowly can pay off with predictably exciting pictures.

If you use a 2¼x2¼ or 2¼x2¾ camera with a removable back, or a view camera or Model 180 or 195 Polaroid camera, multiple exposures are mechanically easy. Simply double the ASA rating, make a shot, insert the slide that releases the removable back, remove the back, cock the shutter, replace the back, and shoot again. With a Polaroid or view camera, just cock the shutter again as Michals did with his Argus C3. It is impossible, however, to double film speed on an automatic camera such as the other Polaroids or an Instamatic. The latter type of camera also has built-in double exposure prevention that you can't beat. Try an SLR or one of the cameras shown in the chart for your efforts.

For the sequence called "The Spirit Leaving the Body" (pages 8–9), Michals

CAMERAS WITH MULTIPLE EXPOSURE CAPABILITY

Following are 35mm SLR, larger format SLR and twin-lens reflex cameras with built-in mechanisms or provisions for multiple exposures. A view camera, or any camera in which film advance and shutter cock are separate, also allows easy multiple exposures.

35mm SLR Cameras	2¼x2¼ SLR Cameras	Twin-Lens Reflex Cameras
Canon EF	Bronica EC	Koni-Omegaflex "M"
GAF L-17	Bronica S-2A	Mamiya C220
Konica T-3	Hasselblad 500 C/M	Mamiya C330
Minolta SR-T 102	Hasselblad 500 EL/M	Rolleiflex 3.5 F
Minolta XK	Kowa Super 66	Rolleiflex 2.8 F
Nikon F2	Mamiya RB67 (2¼x3¼)	Tele-Rolleiflex
Olympus OM-1		
Rolleiflex SL35		

it illustrates the value of taking photographic chances when the odds are with us, rather than taking no pictures because certain equipment was not available. "Be prepared" is a good axiom to follow, but "wing it" is also valuable advice when serendipity provides a positive opportunity for exciting images.

THE PLEASURES OF BLUR

For more than 100 years photographers have been ambivalent about the best ways to capture—or avoid—blurred images. There are times when you strive for sharpness, but there are other situations when you allow a subject to blur on film because (1) using a fast enough shutter speed isn't feasible, or (2) the effects of blur are functional and add to the pictorial impact. Ernst Haas shot a bullfight in blurred color some years ago, and the impression his pictures left is still vivid. Duane Michals often makes the most of blur in his photographs as well.

put his Argus C3 on a tripod and shot each image twice, except the first and last. Each double exposure began with the model lying on the couch. Michals took pains to assure zero camera movement as he re-cocked the shutter and positioned the man in progressively closer stages for the second exposures. Shooting into a window offered contrast problems, but the direction of the light is important to the illusion. Michals positioned a Sekonic light meter next to the prone model and took an *incident* light reading, *i.e.,* he measured the intensity of light falling *on* the model. Had he aimed the meter at the model, the *reflected* light reading might not have been as accurate because some brightness from the window would have influenced it. For the second ghost image everything including the window (in which detail was unnecessary) registered again on the film, though the rising and standing figure is pale because of the light-colored background. This technique results in a negative with more than average density, but Michals compensated by his choice of filter in printing (explained later) to achieve the normal-looking tonal scale you see.

In motion pictures, when actors are seen talking to

themselves the effect is usually photographed against a special background with complex camera work.

For "A Man Talking to God" (pages 30–34, bottom), Michals had no such fancy trappings. Again the Argus C3 was on a tripod, and for each picture he instructed the model to sit at the right and then shift to the left for a second exposure. Gestures and precise placement were planned ahead. "I'm pretty good at remembering relationships," Michals explains. The boxes on which the model sat remained stationary, and Michals aimed for minimum overlap of the knees because he didn't want the series to read "double exposure." In printing, the figure at right was given a few seconds extra exposure because the light grey wall caused more negative density here. The figure at left was less dense on the negative because of the shadow behind it, and this half of the picture was held back while the right half was "burned in" or given extra

printing time.

Of the double exposure on page 47 Michals remarks, "You can't really control perfectly what you'll get on the negative some times, but you know what the possibilities are and how lucky things can happen." Certainly an ability to previsualize is one that other photographers can develop through experience. This special Michals talent is most dramatically demonstrated in

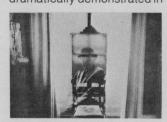

his pictures of René Magritte on pages 48–51. He knew that the artist's form would be well delineated against the dark easel on pages 48–49, and he could anticipate the shifting background image in the picture on the next two pages. While the latter was unavoidable because Michals had no tripod handy,

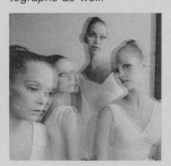

While the four figures on page 1 may first appear as a multiple exposure, Michals says, "The camera moved during the half-second exposure because I leaned against the tripod. It was accidental, and somebody else might have discarded the picture because it was a mistake, but it suits my taste

very well. I think you should use everything the camera does naturally such as blurs and double exposures. It's like a watercolorist using a drippy wash, or an oil painter taking advantage of the thickness of the pigment. Well, a camera makes marvelous blurs, and I like the effect because I like anything that destroys our concept of visual reality. You know people tend to believe photographs, so if you undermine reality, that really shakes them, knocks their conditioned thinking off the track.''

Blurred images *can* be controlled. With experience you can predict approximately how much a moving person or object will move on film. It takes a number of useful mistakes to achieve the knowledge. Three factors join to provide blurred effects: slow film, moderate to weak lighting, and slow shutter speeds.

Slow film: In color, Kodachrome 25 and films such as Kodachrome 64, Ektachrome-X and Agfachrome 64 are all ideal when light levels are appropriately low. In black and white, Panatomic-X (ASA 32) offers the best possibilities, but with *any* film rated ASA 125 to 400 and up, you can use neutral density filters to reduce effective speed. These filters are grey and have no influence on tonal balances. A #2 filter cuts the brightness of a scene in half, a #4 cuts it to one-fourth, and so

NEUTRAL DENSITY FILTERS

Density	Reduces Exposure by (f/stops)
0.10	⅓
0.20	⅔
0.30	1
0.40	1⅓
0.50	1⅔
0.60	2
0.70	2⅓
0.80	2⅔
0.90	3
1.00	3⅓

on. They are a neat way to compensate for a fast film such as Tri-X, or for brighter sunlight than you expected even with slow film. You may also use a neutral density filter for reasons other than blur, of course—to reduce film speed in order to set a larger f/stop to throw a foreground or background out of focus in a scene or still life.

Dim light: Duane Michals never uses neutral density filters because he usually works in rooms where the light is dim. You will find that many indoor situations allow you to shoot at shutter speeds slower than 1/30 second, if you prefer to emulate his technique. Outdoors at dusk or at night the possibilities for blurred images are also enhanced.

Slow shutter speeds: If you shoot a person sitting nearby at 1/125 second, you are assured of a fairly sharp slide or print unless you jiggle the camera. However, at the delightful slow speeds less than 1/30 second (found on most single-lens reflex and rangefinder cameras), the world of blur is yours. With a slow film or a neutral density filter, place your camera on a tripod and shoot a moving subject in dim light or at night. Expose at all the slow shutter speeds on the dial, and compare the blurred results. You'll know better what to expect when you want a certain effect later.

Blurred images are most predictable when you shoot from a tripod or similar firm base. Static subjects are thus sharp in contrast to blurs which are amplified by comparison. If a solid base or tripod is not handy, brace yourself against a door jamb or wall and hold your breath as you depress the shutter release. Although Michals ordinarily uses a tripod with slow shutter speeds, he did not for the bottom picture on page 21, about which he says, ''I set this up with two people for the theme, 'chance meeting,' and I hand-held the camera for maybe ¼ or ½ second using Tri-X normally at ASA

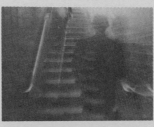

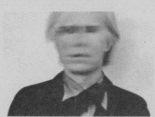

400. I welcomed the extra movement I got without a tripod, because I was working on the idea of a dream, and the blur destroys reality so well.''

It would have been possible to shoot the three pictures of Andy Warhol (page 25) by starting at the top with a fairly fast speed and then slowing to 1/30 second, ½ second and 1 second, meanwhile having the model move his head more and more. Duane Michals chose another method, using his Argus C3 on a tripod. He explains: ''I was stopped down to f/16, and the top picture was probably at 1/60 second. For the others I made a *series* of exposures at ⅛ or ¼ second, and asked Warhol to move his head more and more as I shot the overlapping images. On the last one I told him to really let his head go bananas, and the shutter was open long enough in total to obliterate his features entirely.''

If you try progressive blur yourself, be sure that the model tries to hold his shoulders still to contrast with the movement that will show above them. By shooting at slow shutter speeds while also making multiple exposures (especially with a camera that is mechanically outfitted for same), you'll have a valuable series of comparison shots that become your ''manual of blur.''

For ''Margaret Finds A Box'' (pages 26–28, bottom), the child and the moving box

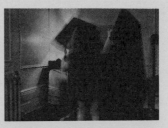

blurred at ¼ second. In the series called ''The Incubus'' (pages 31–33, top) Michals varied exposures between ½ and 1 second. He explains, ''I asked the model in the horse's head to move from fast to faster to fastest. One action and exposure is going to be right, though you cannot precisely anticipate blurs.''

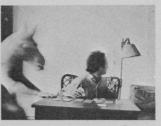

Michals makes an asset of the unknown, as you can as well. The varieties of blur are infinite because of the possible combinations of film speed, light level and shutter speed. In two further exam-

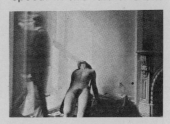

ples, the man moving out of the frame at left on page 44 was shot at ½ second, which was slow enough because his movement was across the scene. A subject coming towards the lens would have required a longer exposure to show as much blur. And for the picture of Warren Beatty (page 58) Michals was quick to see the value of the

blowing curtain, which he terms "the presence of the invisible," to add visual drama to the portrait. Even if you're not trying to create a specific illusion, blur can be decorative and unusual.

IMPROVISING A STUDIO

As evidence that Michals takes pride in turning ordinary places into photo-

graphic sets, look at pages 2–3 and page 73. The dancer's legs were shot in the trunk storage room of the Saratoga Performing Arts Center with natural light on Kodachrome II. He built a makeshift "stage" of sawhorses and plywood, draped it and the background with white muslin, had the dancer grasp a water pipe off camera for stability, and made long exposures such as ½ and 1 second using a Nikon on a tripod. The plain wall of a room served as background for the double portrait on page 73, underlining Michals' feeling that people are more readily put at ease in their own environment than in a big, official-looking studio.

Light in color and black-and-white. Rooms in many homes have unpatterned walls near windows or large glass doors that can be helpful in improvising a studio. You may not be as dedicated as Michals is to avoiding artificial light, and both blue flashbulbs (or cubes) or electronic flash are suitable for additional light with daylight color films. Keep in mind that the color of light changes according to its source: differences in such colors are measured in Kelvin temperature. Daylight can be 5500°K (as degrees Kelvin is

expressed) and higher, so daylight color emulsions are made to match. The color temperature of a tungsten floodlight may be 3400°K or 3200°K; Type A Kodachrome matches the first figure, and High Speed Ektachrome Type B is balanced for the second.

If you mix daylight and floodlight (or ordinary electric room light) in the same picture, floods register as too "warm"—too rosy—on daylight film, while on tungsten-type emulsions, daylight registers too "cold"—too blue. Thus the recommendation that you balance daylight with blue flash or electronic flash to achieve the right Kelvin temperature. As for fluorescent lights, you may have seen how they turn skin tones green on color films. To correct that ghoulish look, use an FL-D filter with daylight films and an FL-B filter with tungsten films. The FL filters are often a compromise, depending on the color of the fluorescent tubes, but they are far better than nothing.

Of course, with black-and-white films, either floods or flash are suitable to match daylight. You get a softer, more pleasant effect if you bounce light off a reflector or umbrella rather than aiming the light directly at the subject. Reflected light also complements window light more harmoniously.

Backgrounds. Despite Michals' disdain for seamless (also called no-seam) background paper, it can serve the average photographer very well. Sold in 9-foot-wide rolls at well-supplied camera shops, seamless paper comes in white, black and a variety of colors. Plain walls are fine for portraits, but to shoot full figures and avoid the background line where wall and floor meet, seamless paper is a great accessory. Either tape it firmly to a wall and let it flow onto the floor (where you must make an effort to avoid footprints and rips), or hang it on a Pole Cat or Pole King. The latter consists of a pair of poles ad-

justable for ceiling height and held in place by springs, plus a detachable cross pole on which you put your seamless roll.

The possibilities of a home-made studio are endless, depending on the amount of space you can clear. Even if a room lacks illumination from outdoors, you can make good use of electronic flash or floodlights, especially bounced or reflected. With enough light and fast film, you can hand-hold your camera, but with fairly static subjects (young children excluded) working from a tripod is usually advisable. The tripod allows you to use long exposures, and when you move to adjust a light your camera stays in place.

SHOOTING REFLECTIONS

If you try to shoot into a store window, reflections from surrounding subjects can be irritating, especially when they confuse or blank out parts of a scene that you want. You can use a polarizing filter to overcome some reflections, depending on the angle at which you shoot. On the other hand, Duane Michals often includes reflections in his pictures as a welcome addition to the scene.

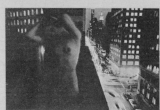

Although the nude on the rooftop (pages 4–5) may appear to be a bit of darkroom magic, everything you see is on a single negative. In the top left, buildings across the street are reflected in a glass door behind the woman that Michals had opened to just the angle he wanted. The setting is a rooftop with no light at the left; exposure on Tri-X was about ½ second at f/4 with a 28mm lens. Nude and cityscape gain a kind of mystery from the reflection.

Focusing accurately can be a problem with reflections, but the solution is to calculate depth of field. If you focus on an image in a mirror, you find that the footage setting on the lens is not the same as camera-to-mirror; it includes the additional distance from the mirror to the object being reflected. When you want to be sure that an entire scene will be sharp, focus first on the nearest object and then on the reflected image, if that will be farthest. By reference to the depth of field scale on the lens barrel, be sure both close and far distances are included for the f/stop chosen. As an example, if you want everything between 7 feet and 50 feet to be in focus, set the f/stop that assures this depth of field, and adjust your shutter speed accordingly. A wide-angle lens is helpful, as is fast film, when you must shoot at small apertures for good depth of field.

Michals also demonstrates how to avoid reflections in the "Empty New York" series that he began in 1964. The first, second, and fourth pictures on pages 20–21 are interiors taken through windows as Michals pressed his wide-angle lens against the glass to block his own reflection. If he could not shoot this way, he would try to hide his reflection with a hat or by positioning himself to one side. You have to experiment with reflections. The time of day and the angle of the light can influence the results. At night, if nothing opposite the window is bright, reflections are no problem, and you can do delightful things on a tripod with long exposures.

Michals' ingenuous use of reflection shows up again in the picture of David Hemmings on page 59, and on page 77 window reflections

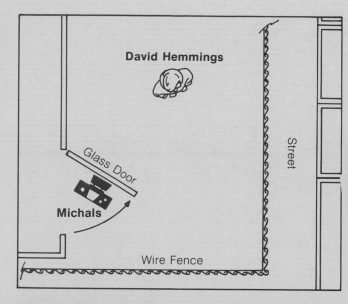

help frame the subject. He has converted a "curse" to an asset. Reflections enhance his photographs just as blur and multiple exposures do, even though all can be annoying in some circumstances.

EXPOSURE AND PRINTING

For most photographers the advent of reliable exposure meters built into the camera was a blessing. Once you learn the characteristics of a built-in meter, you can trust it. Not Duane Michals, who prefers to use a separate hand-held Sekonic exposure meter. He feels that the separate meter gives him a more precise reading of the exact spot he wants to expose for than the camera's through-the-lens meter. "When it's a portrait, I expose for the face."

The hand-held meter suits Michals best, but unless your integral camera meter is old and/or unreliable, it is quite adequate for almost any exposure condition. Some camera meters average the light reflected from a scene into the lens, and give you a proper compromise read-

ing. Others have a dual system with which you can switch from average to "spot" metering. This means only a limited area or spot is measured, and an exposure for it is indicated. Both methods can be practical, though spot metering is handier for subjects far away (on a stage, for instance), or a specific area that has priority over the rest of a scene.

The technique called *bracketing* can assure proper exposure in unusual lighting conditions, especially if you are using color film. To bracket, you shoot at the shutter speed and f/stop that the meter indicates, and then adjust one or the other of those variables by half a stop or a stop on either side of the "correct" setting. In this way you get color slides with

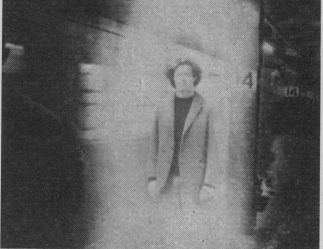

a variety of saturation or brilliance, or black-and-white negatives with several densities, one of which will print better than the others. For instance, if a subject is backlighted, such as the

series "For Balthus" on pages 22–24, you might bracket exposures to be certain you get shadow detail. Michals himself seldom brackets, partly because he knows from experience how to use an exposure meter for the type of negative or slide he likes.

But that is only part of the reason. Michals has a lot of latitude in exposure of black-and-white films because, unlike many pros, he does his own darkroom work, develops his own negatives and makes his own enlargements. This gives him creative control that might elude a lab technician, and relieves him from having to give complicated verbal instructions for the atypical results he requires. If you shoot black and white and follow through with the completion of pictures in the darkroom, there is a wealth of control, experimentation and satisfaction at your fingertips.

Michals prints on Kodak

Polycontrast papers which, like Dupont Varilour and Varigam, are made in a single grade (but various surfaces and weights); contrast in the print is regulated by changing filters on the enlarger. A #1 filter is used with a very contrasty negative, a #4 filter with a negative of minimum contrast, and filter numbers in between apply to normal or slightly thin (uncontrasty) negatives. Possibilities for variety are great because you might print the foreground of a scene with a normal #2 filter, and switch to a #1 for a contrasty sky or a #3 to give more brilliance to a portion that would look too flat otherwise. Michals develops his enlargements in Dektol, a standard Kodak paper developer, and because his judgment is acute, his prints have a long scale of tones from deep black to bright white.

Here are some of the pictures that required the photographer's special darkroom magic:

Michals calls his sequence, "The Human Condition" (pages 26–27, top) "the most complicated printing job I've ever undertaken." The first picture is a straight shot of a man in a subway station. The second is another frame from the same roll; he held a piece of rectangular cardboard above the paper in the enlarging easel, rotating the cardboard slightly during most of the exposure to keep it from projecting a sharp edge. Because a portion of the projected image was thus held back or "dodged" during the exposure, this area appears lighter than the rest. Having copied a star photo from a book (see at left), he then *sandwiched* that negative with the original of the man to make picture #3. Sandwiching simply involves placing two negatives in the enlarger together and printing the combined image. For the fourth picture he printed the sandwich again, but dodged the center portion, and allowed the edges to

appear in more detail. The star photo by itself was printed in #5 and dodged on the left side, and printed again in its entirety for #6.

Copying with a 35mm camera is relatively easy. You usually lay the picture to be copied on a table in even daylight or illuminate it with two floodlights, equidistant from each side. The camera may be on a tripod or attached to a copy stand which looks like an enlarger with base and post, except that your camera is mounted instead of an enlarger head. Using closeup attachment lenses or closeup rings on a normal lens (the 50mm), or a macro lens made especially for closeup work, you simply position the camera to photograph whatever you want of the material to be copied, and expose according to your meter reading.

Michals copied the star picture on 35mm film at a size he knew would work in proportion to the image of the man in the subway station. He made two or three negatives closer or farther from the picture in the book, and chose the one that matched best in a sandwich format. A similar technique with a different set of negatives was used for the series on page 35.

For "The Illuminated Man" (pages 54–55), the model

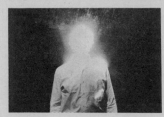

stood in an intense shaft of light in which he was "dissolved" to lose his identity. Michals took an exposure reading on the man's face, and then opened the lens one stop above it and used a shutter speed one step below it. In this way the brightest area was overexposed by the equivalent of two stops, and when the negative was printed with a #3 or #4 filter, contrast was again amplified. Similar patches of light often appear in nega-

5: Print No. 4 reflected in hand held mirror, then photographed.

tives by accident, and are often annoying, but when you can put the effect to symbolic use, high contrast pays off.

In the mystic sequence called "Alice's Mirror" (page 96), Michals indeed "plays around with reality," to a point where you do a double-take, even after studying the pictures several times. Michals explains how he arranged this *tour de force:*

#1: A miniature chair and a pair of glasses were photographed on a stove. Says Michals, "I set up a contradictory situation so you think, 'What the hell is that?'" He used a Nikon F2 with 35mm lens for all but pictures #1, #5 and #6, which were made with a 50mm lens.

#2: The camera was moved back to show the stove with chair and glasses from picture #1.

#3: Turning to a mirror on a stand atop a bare table, Michals adjusted his camera so the stove was reflected in the mirror. To hold the whole scene in focus, he stopped down to f/16 at ½ second, and checked the limits of sharpness by previewing depth of field both in the finder and on the scale around the lens barrel. It took time: Michals shifted the

camera, the mirror and the stove many times, one at a time, until he had them in position and sharp.

#4: Now the subject is a seated man holding another mirror in which is reflected the small mirror perched on a table top almost at eyelevel. Again depth of field maintenance was critical, but easier to attain than in #3 because the camera was farther from the subject.

#5: Here's a hand holding a third mirror in which is reflected the image of a *print* of picture #4. Using a macro lens for this and the next closeup, Michals' problem was to get the hand to hold the mirror at just the right angle to reflect the print, which you see reversed. Careful composition through the single-lens reflex finder is evident, but by now we recognize this as a Duane Michals trademark.

#6: Backing away slightly from the same hand, now holding the mirror as though it has just been crushed, Michals again positioned the same print of #4 to reflect in the pieces. It makes a shattering conclusion.

Technically speaking, Duane Michals tests reality often and gives us new visual dimensions to challenge our own photographic limits. You will understand much better how and what he did if you try some of these experiments yourself. Double expose, overexpose, play with light and reflections, think in sequences as far from the literal as you like, and stretch your imagination. You wouldn't want to copy him directly, but you can take off with some of Duane Michals' unusual techniques to enjoy new and exciting facets of photography.

For his brilliant Vogue *story on George Balanchine and the New York City Ballet (see following pages), Michals posed the master choreographer in the woods wearing a clown's costume from* Pulcinella.

ALICE'S MIRROR

Stove

1: Close-up of chair and glasses.

2: Medium close-up of stove including chair and glasses.

Man holding mirror

4: Reflection of shaving mirror in large mirror held by man.

Shaving mirror

3: Stove reflected in shaving mirror.

Michals

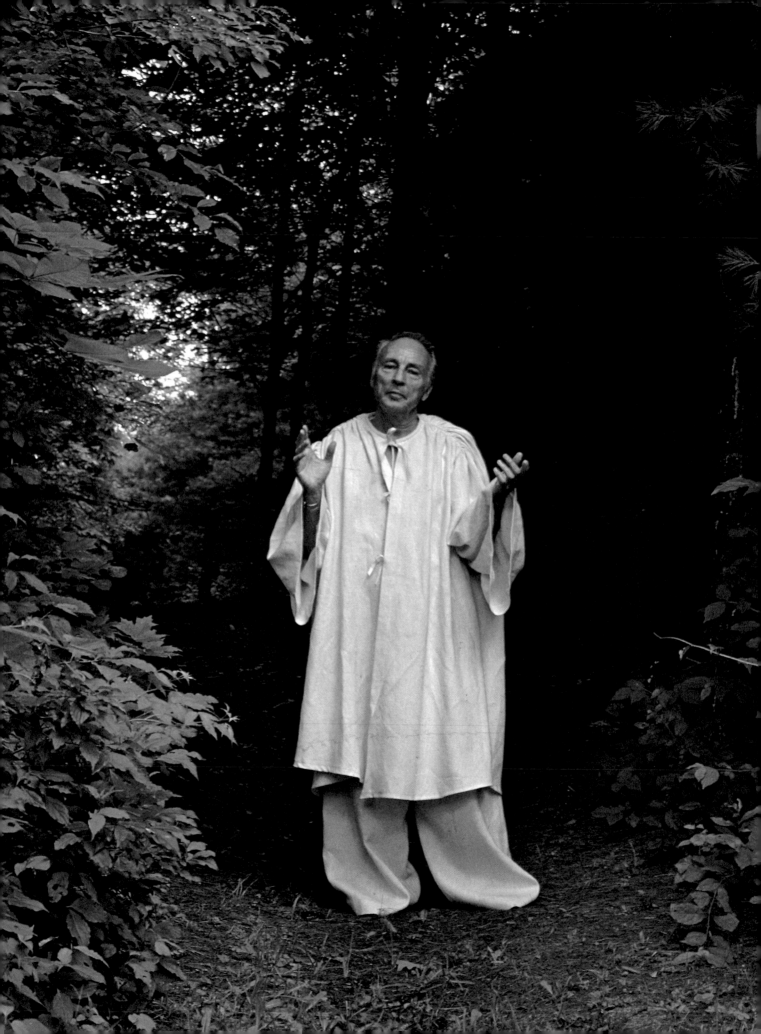

Romantic tradition: Melissa Hayden

Pure dramatics: Edward Villella in "Prodigal Son"

Pageantry: "Pulcinella" decor by Eugene Berm

R
Balanchine—
"Bu

The Genius of George Balanchine:

Rowdy to witty fun:

Nobility, swift grace: Helgi Tomasson

High camp: 'Pulcinella' transvestite

American vitality: Jacques d'Amboise

The richness of collaboration: "Firebird"
Stravinsky, Balanchine, Robbins, Chagall

The use of stillness: Sara Leland

The power of myth: Francisco Moncion

Disciplined vivacity: Violette Verdy

91

The best equipment: Imagination

Most of Duane Michals' projects—personal and commercial—consist of days of cerebration and only a few actual clicks of the shutter. But in 1972 he was confronted with a challenge far different from his familiar sequences, single images or portraits. *Vogue* asked him to undertake a full-scale photographic treatment of the great choreographer George Balanchine and his New York City Ballet. Although the assignment did not require the kind of tightly knit development that a traditional photo essay would have needed, it demanded a large variety of pictures to illustrate the many facets of Balanchine's genius. It took nearly a month, resulted in 12 color pages, and fully tested Michals' resources of technique and imagination.

For this job, he did do some research. Before he began shooting, Michals went to performances at Lincoln Center to familiarize himself with Balanchine's work. He also worked closely with the story's editor, Leo Lerman, a colleague with whom he had worked on personality assignments for both *Vogue* and *Mademoiselle.* ''I love to work alone,'' says Michals, ''but sometimes it's really good to have an editor around, especially if you're doing ballet and don't know much about who's who and what the proper poses are.''

The shooting took place at the Saratoga Performing Arts Center in upstate New York, where the ballet company was in its summer season. Since Michals wanted all of the photographs to be ''created,'' none were shot during actual performances. His first task was to find intriguing settings and interesting light. He found both elements in the woods surrounding the center and in a couple of nearby mansions whose elegant old furnishings grace several of the pictures shown on pages 90 and 91.

For the story's lively opening photograph of children from *The Nutcracker Suite* (pages 12–13), he chose as the stage a clearing in the woods at dusk. He perched on a stool and, using high-speed Ektachrome because of the fading light, shot while the children jumped up and down at his command. ''Children are wonderful and rotten,'' he says. ''They're difficult to control. There were some frames where a few of the kids looked terrific and others had their finger in their nose. Kids lose interest after about 10 minutes. And once they get cranky, forget about it. Money, candy, ice cream—nothing will get them to do what you want.''

Michals' interest in art helped in several situations. In a courtyard, he posed three classic young ballerinas, sculpture-like as ''The Three Graces'' (at right). And his passion for surrealism enabled him to make use of a technical goof. He was shooting a fairly

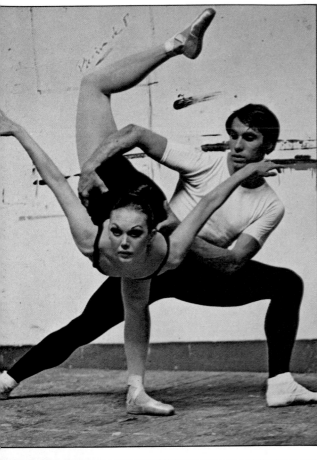

Allegra Kent and Jean-Pierre Bonnefous in the brilliant "Agon" pas de deux

BALANCHINE'S FOURTH DIMENSION:
His Eye and Mind
Transform Sound into Sight
By Lincoln Kirstein

To start, let us assume certain facts which appear to be, at least statistically, verifiable. There is no important dance company in the West today that does not desire to have included in its season one or more of George Balanchine's ballets. The Royal Ballet alone this winter is presenting three of his works new to the British repertory. There is no state or civic company in Europe east of the Iron Curtain, in Canada, Australia, or South America that ceases to make urgent requests for more of the same. Of what other living choreographer is this true?

Music is partner to dancing. Balanchine was the self-chosen colleague of Stravinsky for half a century, the most important and fertile collaboration of its kind since Petipa's with Tchaikovsky. Furthermore, Balanchine has been credited with (or, often as not, accused of) choosing and establishing a contemporary archetype, journalistically labeled "the Balanchine dancer": a tall, slim girl with a small head, long legs, cool temperament, and athletic virtuosity. No other choreographer, past or present, has had attributed to him or her so severely idiosyncratic a choice. Also, in proficiency, prolificity, musical capacity, and personal style, Balanchine occupies a contemporary position that is isolated, prominent, and, to a degree, popular.

This says little of the quality or variety of his accomplishment, of his work's wit, elitism, arrogance, passion, or playfulness. These vibrate as subjective judgments. If "beauty is in the eye of the beholder," so then is elitism, arrogance, and the rest. These abstractions do not refer specifically to Balanchine's choreography, his maps of movement, but rather to an overall atti-

tude governing the nature of dancing itself. Balanchine's means for composition—measured first by a sonorous metric: music—are at once highly personal and radically academic. They subsume his notion of the training of performers, which precedes a choice of dancers with whom he feels he can work. This depends not only on a preference for a certain type of physique as raw material but also on the acceptance of a discipline by aspirants from the first stages of instruction. As he told an anxious mother thirty-five years ago when she was worried about whether or not her greatly gifted if headstrong daughter would ever become a ballerina (with a capital "B"), "La danse, madame, c'est une question morale." (P.S. She did; and it was not a question of morals, which were local and lax, but of morale and morality, which were solid.)

The platonic ideal of "a Balanchine dancer" is not necessarily an androgynous nymphet who might as easily be an Olympic champion fencer, skater, diver, or equestrienne. In popular terms, however, mastery at peak levels in these sister disciplines roughly illustrates his requirements. It may be noted that in such display, one element is lacking: self-expression, personality; what used to be called "soul." The aims of sport are not those of art. The chief competition a dancer faces is in a mirror; it is the image of a self whose imperfections must be conquered, whose perfectibility must be exercised if any perfection is ever to be won. There are no statistical records to be broken nor championships to be won. The supreme judges are teachers and ballet masters to whom an aspirant commits herself or himself. When applause (Continued on next page)

123

conventional portrait of four ballerinas when his leg happened to bump the tripod during an exposure. This produced a subtle second image of each girl (page 1)—a picture with the dreamlike elusiveness of Michals' personal work.

But above all, Michals prized the images he made backstage at the center in a cluttered trunkroom which he converted into a studio. He liked the northern light from the windows there, and in its path he built a makeshift little platform of two sawhorses and a piece of plywood. Over this he draped a backdrop of white muslin fabric scavenged from the ballet mistress. ("I hate seamless paper," says Michals. "I don't see how anyone could face it all day.") On this stage, a ballerina demonstrated various leg positions (pages 2–3). Luckily, a water pipe ran directly above the platform and she clutched it to avoid movement during the slow exposure dictated by the color film. Then, in a typical stroke of Michals' fairytale imagination, he turned his improvised studio back into a cluttered trunkroom —and made just the right double-truck picture to close the *Vogue* layout.

The Michals magic also has begun to transform the way many young photographers view reality. Long more popular in Europe than at home, he is now in great demand at campus and museum workshops across the United States. Students are beginning to see with their minds and many are attempting to work within the sequence form. "The American personality has generally had a cheerleader, change-the-world point of view," says Michals. "There was

always something decadent, self-indulgent, un-American about using the imagination. You had to be masculine—you had to go out and photograph a war. But that's not news anymore. In the younger generation there's a whole new awareness of their own lives as news."

Michals recognizes the limits imposed by still photography and sometimes frets that his ideas will become so abstract "they won't be photographs anymore." He intends to go on writing with his pictures, purists be damned. "I want to break more and more away from the narrow definitions of what different artists are," he says. "If in the future I feel I can express myself even better by writing, photographing and tap dancing, then I'll do that."

Meanwhile, his mental shutter keeps clicking. Recently, he was writing personalized captions in an album of his photographs—one of a limited edition that sells to collectors for $1500—when he began to muse aloud to a visitor. The glimmer of a new sequence was flickering inside Michals' gleaming skull, a sign that soon he would be casing apartments and moving like a moth to the right light, to record on film—ephemeral though it might be—the reality of his own mind.

"Maybe we have communal dreams," Michals is saying. "We always assume our dreams are private. But what if there's a red-headed guy in Chicago having a dream about a bald-headed guy he encounters on the street, and what if the bald guy wakes up in New York and remembers this dream about seeing a red-headed guy in Chicago and. . . ."

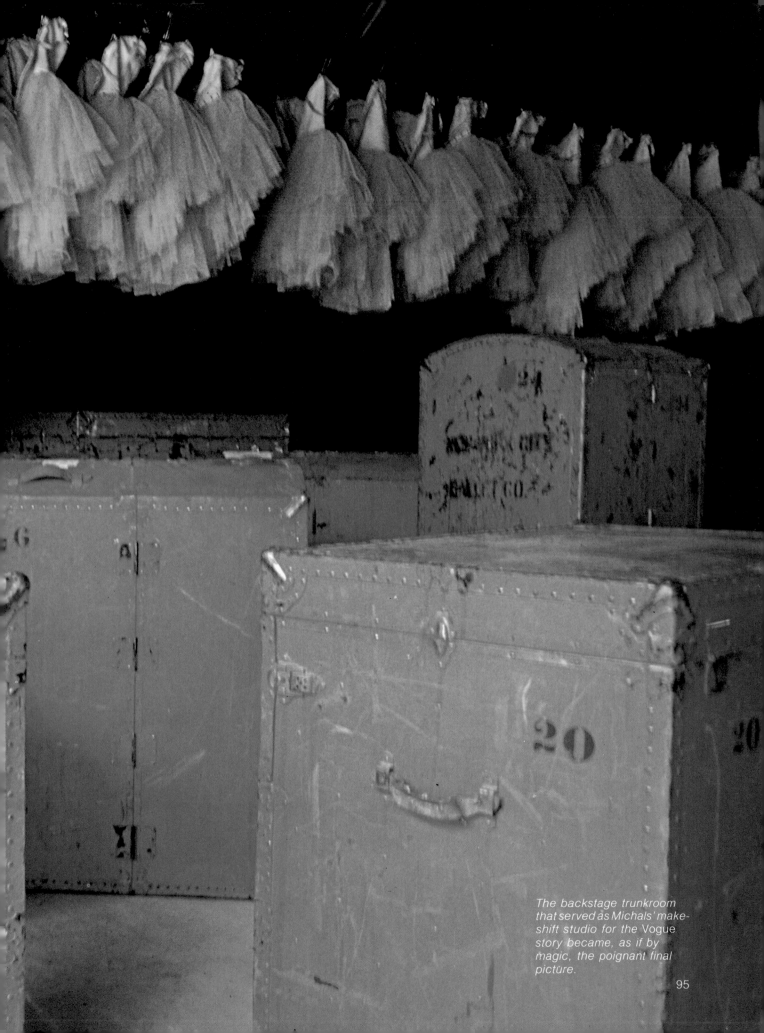

The backstage trunkroom that served as Michals' makeshift studio for the Vogue story became, as if by magic, the poignant final picture.

95

Alice's Mirror

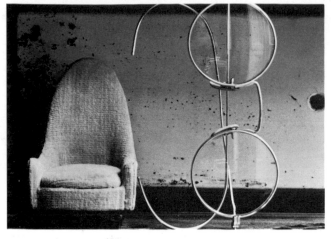

One

Two

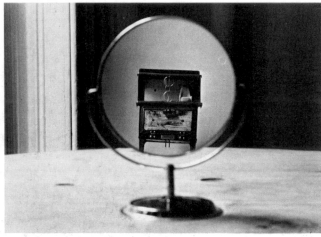

Three

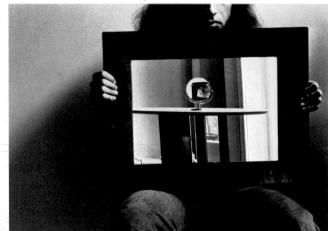

Four

Five

Six

"Alice's Mirror."
This Michals-in-wonderland sequence uses the tools of surrealism—scale distortion, mirrors within mirrors and even photographs within photographs—to shake up and finally smash the viewer's sense of reality.